Film Actors

Volume 17

Robert Taylor

Documentary study

Part 1

ISBN-13 : 978-1512380613
ISBN-10 : 151238061X

Copyright©2012-2014 Iacob Adrian
All Rights Reserved.

Notice

This documentary study use historic, archived documents.

Because of this, some pages may look blurry or low quality.

Still are included in this book because they have

high value from critical, documentary, historical,

informative and journalistic point of view .

Dtp and graphic design

Iacob Adrian

Copyright©2012-2014 Iacob Adrian
All Rights Reserved.

Author statement

The actors and actresses are the the bricks .

The cast and crew are the plaster .

They stand on the foundation created by producers and writers and directors .

All these people creates the great palace of the art of film .

Iacob Adrian - 2013

This little Book conveys the greetings of

..

to

..

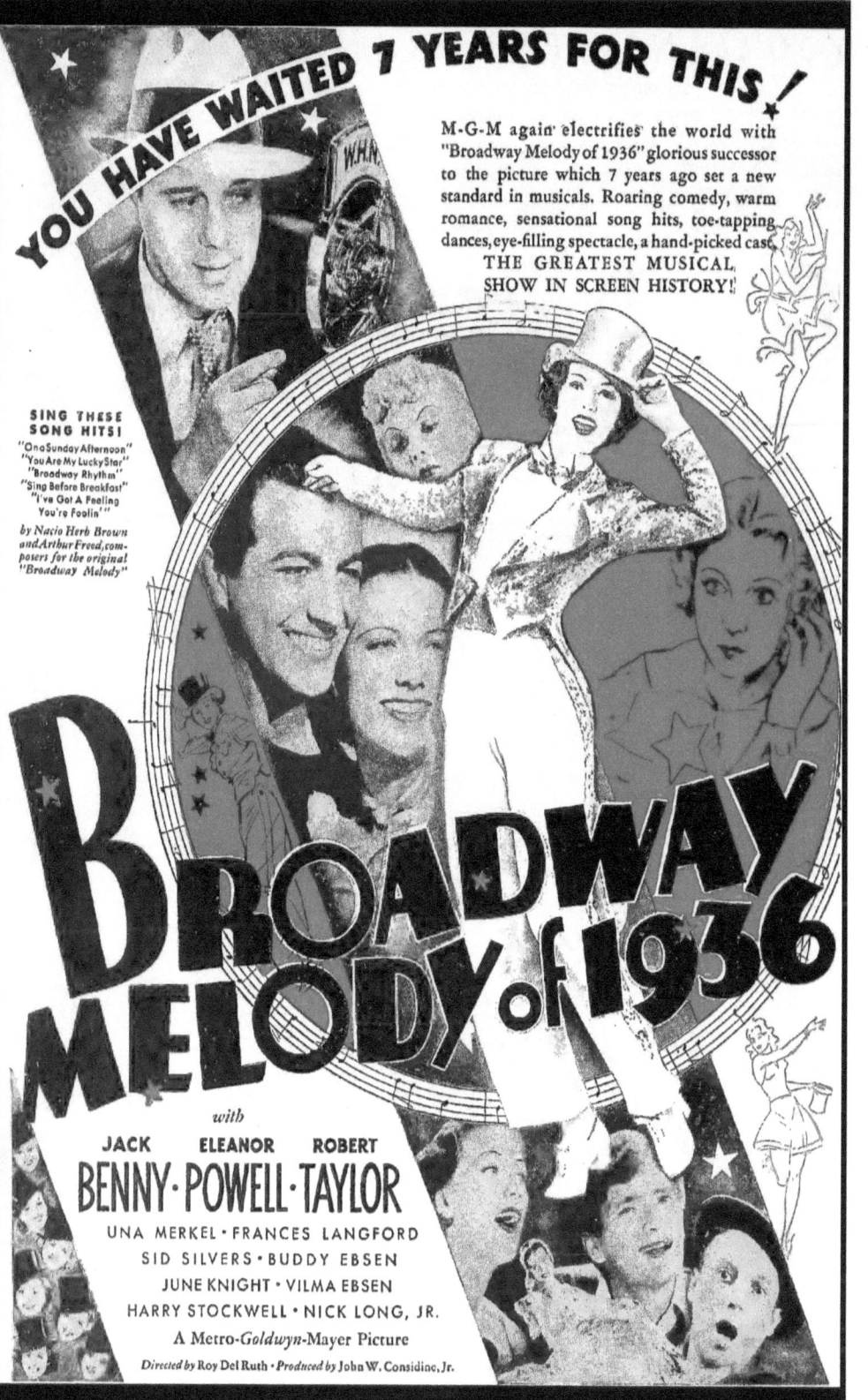

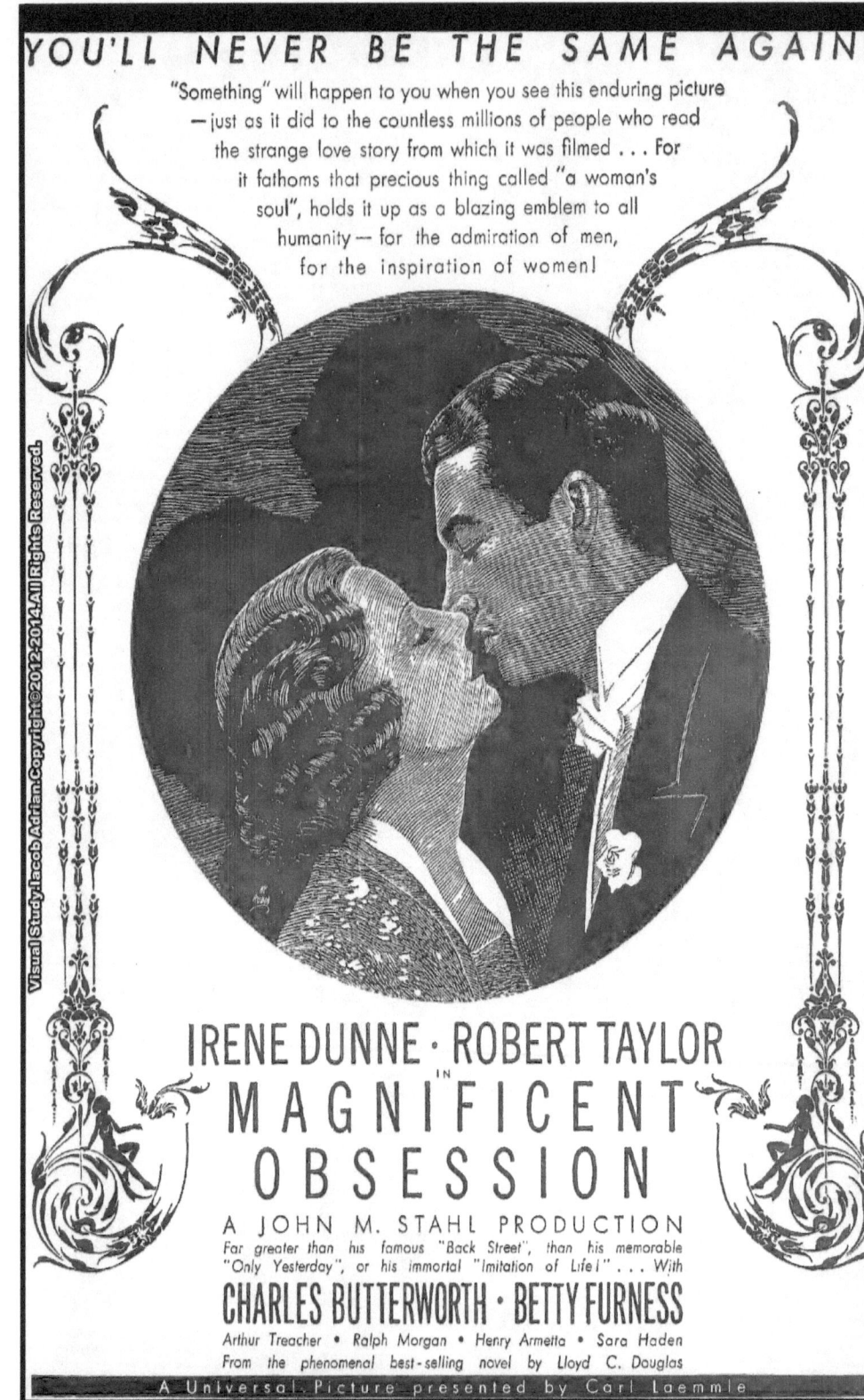

How Hollywood Invested in BOB TAYLOR

They gave him a secret "allowance" when he couldn't buy peanuts, and he spent his way to screenland fame!

by ANITA KILORE

IF EVER HOLLYWOOD has had a male Cinderella, Bob Taylor is it! And as every Cinderella, even a boy one, has a wand-waving fairy godmother, so also has Bob Taylor had one. And that fairy godmother has been none other than Hollywood itself.

There is only one false note in this Cinderella simile. Bob Taylor never wore rags, never slaved at any kind of work... never has been without a fond and loving parent. He has always been the best-dressed male in Pomona, his home town. He has always had pocket money, and something to ride around in... and he is the one and only child of the dearest mother a boy ever had.

So why a Cinderella? Because if you're not known in Hollywood... if you don't get your name in the papers, if nobody talks about you... you're just as much of a nonentity as Cinderella was before her fairy godmother brought her out of the kitchen. In other words, in Hollywood, the important step is not transforming rags to riches. It's more important that the wand-waving change dull oblivion into bright and sparkling spot-lighted fame.

And just signing a contract with M-G-M did not accomplish the trick for Bob. It might have, except that shortly after M-G-M took him, the news leaked out that he had been signed for $35 a week—about the lowest salary every paid a contract player.

Ho! said the scribes. He can't be anything much! And, accordingly, they left him out of their papers. Hollywood has a new twist on that old saying, "Out of sight, out of mind." It is "Out of the papers, out of everything." And out of conversation particularly. Even the gossips didn't consider him as a palatable subject.

● BOB GOT DISCOURAGED... not because of any of these things... but because he couldn't seem to get even a small part in any M-G-M pictures. He began to wonder if he was really suitable for pictures, if he really had a future in them. And, like a sensible person he went to Louis B. Mayer to ask him just that.

Mr. Mayer talked to Bob as though he were his own son. He told him not to worry himself to death, but while he was waiting for his chance, to interest himself in some subject besides pictures, as a

The Command Story

The youngsters grab the spotlight! You voted for this story and here it is. Send in your next request

Bob Taylor's personable smile has won him many friends. Here he is at a recent preview with Irene Hervey and Bill Henry, two up-and-coming young film players

—Charles Rhodes Photo

How Hollywood Invested In Bob Taylor

study or a hobby. So he could get his mind off pictures for a rest.

But when Bob left Mr. Mayer's office, that astute gentleman decided that he would do more for the boy than just reassure him. And here we're telling for the first time how a Hollywood godmother works . . . in coaxing and cajoling fame for her favorite.

Suddenly Bob Taylor blossomed out with six of the smartest suits that Hollywood tailors could devise. And believe me, even the tailors caught the spirit of the game and outdid themselves. And in less than a week Bob was being nominated for the best-dressed man-about-town title. Score number one for Bob's fairy godmother.

Next Bob had a new car . . . bright, shiny, black . . . luxurious. Now people noticed him as he whizzed by. Score number two.

Then Bob began appearing at all the swank night-spots. He dances beautifully, and on one occasion when he appeared with Jean Parker, at the Beverly Wilshire Gold Room, the other guests held their breath while they watched these two graceful young people gliding magnificently about the floor. The guests held their breath watching them, and when Bob and Jean left, the waiters and the maitre d'hotel caught theirs. Bob's check was in keeping with that of a movie star's, and his tip was a gesture worthy of a celebrity. Score number 3, and a big one.

But LONG before this score was made, Bob had begun to work. First in a "Crime Doesn't Pay" short subject. Then in a full-length picture, Society Doctor . . . and no sooner was this picture released than Bob's fan mail began pouring in by the basketful. It was then that the news also got around that Bob had a secretary, to help answer that mail. And when you have a secretary in Hollywood then you're really in the swift stream of fame. Without one you float along in sluggish waters. The secretary was score number 4.

Now the papers began mentioning him . . . "Last night at the Gold Room . . . Bob Taylor looking more handsome than ever. . . ." "Bob Taylor, a picture of what the well-dressed man will wear this season. . . ." "Bob Taylor and Jean Parker." "Bob Taylor and Irene Hervey. . . ." Bob Taylor, Bob Taylor, Bob Taylor.

The wand was working.

Because it was M-G-M who was paying all the bills . . . even the tips to waiters.

All this is changed now of course. For when option time came around, M-G-M tore up his old contract and gave him a new fat one . . . and now Bob can pay his own bills, and is glad of it!

M-G-M's Mr. Louis B. Mayer wasn't the only one to invest in Bob Taylor. There were others who, though it cost them more money, did give Bob plenty of help and good advice. For which he is grateful. (Though knowing Bob, there was much of it that he probably didn't need, because Bob is a young gentleman with a good head on his shoulders, and good breeding in his veins.)

"But there was one bit of advice that everyone everywhere gave me," Bob told me, "that was the best thing that ever happened to me. Studio officials, friendly

Hollywood

WIN CHARLES BOYER'S PORTABLE PHONOGRAPH

5¢ a copy

SEPTEMBER
NSC

5¢

Study-Jacob Adrian.Copyright©2012-2014.All Rights Reserved.

Natural Color
Photo of
JOAN CRAWFORD
ROBERT TAYLOR
in
"The Gorgeous Hussy"

JOAN CRAWFORD TALKS ABOUT BOB TAYLOR

The Star Who Doesn't

Fair Damsels May flutter and palpitate in a thousand movie theatres while Robert Taylor is on the screen, but that young man is blissfully unaware of these flurries.

Even a flight to New York for personal appearances and a radio broadcast, during which he was mobbed by fan-atics who grabbed a shoe, a tie, and lifted him bodily from the sidewalk, has failed to convince Bob that he now out-ranks Gable as No. 1 star of the country.

When told this fact on his return, he poo-pooed the whole fantastic idea. Believe it or not, he does not know he's famous!

The logical reason for this phenomenon is usually overlooked in a town accustomed to pomp and glory and fireworks accompanying the sensational success of a player. No such blaze moves through the studio when Bob Taylor reports for work with such stellar luminaries as Janet Gaynor, Loretta Young, Irene Dunne, Joan Crawford. Bob was not reared to expect a fuss to be made over him. He is acutely embarrassed by any kow-towing.

Spend twenty-one of your twenty-four years in Nebraska, and you'd know why this is the case with Taylor. He rode his own cow ponies from the time he was eight years old. All about him was a limitless, calm horizon. In the little town of Beatrice, where he grew up and went to school, the Hollywood style of putting on "front" was unknown.

The only son of Dr. and Mrs. Spangler A. Brugh (Taylor is his screen name), Bob could have become a spoiled child in his formative years. Only sons usually are, particularly in a family of considerable means. The Brughs, aware of such dangers, firmly avoided the temptation.

Robert Taylor's start toward stardom was innocuous, but a steady succession of hits has placed him at the very top

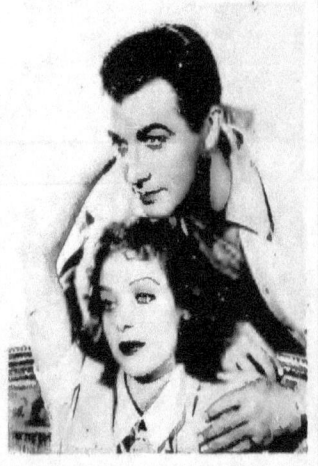

Every time Taylor co-stars with a dazzling lady, romance rumors start up. You've probably heard them about him and Loretta Young, who played together in *Private Number*

Know He's Famous...

As a result his habit of mind is fixed upon their rules of living: innate modesty, good manners, good taste, and moderation. Valued traits, these, which are so thoroughly ingrained as to protect the son fully against gaping pitfalls prepared for all Hollywood stars. Make no prediction of a rush of vanity to the head in this instance.

Proof Of His Calmness

● ACTUAL INSTANCES, HOWEVER, will best demonstrate the odd fact that a star can be unaware of his fame, even with the entire country in a furore.

It was during the filming of *The Gorgeous Hussy*, starring Joan Crawford with Bob playing the lead, that he was invited by HOLLYWOOD Magazine to join a group entertaining seven contest-winning girls. An apology would have been accepted from him for inability to attend, for picture making is gruelling work—yet Bob was first to arrive and graciously did his part. Such courtesies are not common in starland.

Realizing that this was an unusual young man indeed, we quietly investigated the facts in the case.

At his studio an effort was being made to induce Bob to make a personal appearance in New York. For reasons he kept to himself, Bob did not want to go. And this is why, as he informed your HOLLYWOOD reporter:

"I'm afraid the studio will discover I'm not such a good drawing card, after all."

This surprising attitude is difficult to believe, yet it is no exaggeration.

Having never been to New York, Bob was inclined to think that his arrival would create no especial excitement. True, Nelson Eddy came back to M-G-M with echoes of his receptions still ringing in his ears, but Nelson, according to Bob's point of view, is another story. "Even without his magnetic personality, his voice would make him great," Bob points out—with considerable logic. "I am by no means an important actor with a stage following. I have no remarkable talents. I'd rather stay here and go on working my way up."

We pointed out the publicity value of a cross country trip—how reporters and cameramen would bombard him at every stop from Albuquerque to Yonkers.

Bob grinned amiably, and shook his head. "That would be a pretty hard job for any studio to arrange," he insisted.

First Trip From Home

● ONE REASON FOR his naiveté is his utter lack of conceit or professional jealousy. Another is his home training. He was eight when he climbed his cowpony for a fifteen mile ride to his grandmother's place. His father, the town's

Next in line for Bob Taylor is *Camille*, starring Greta Garbo. This composograph shows how they will look in love scenes

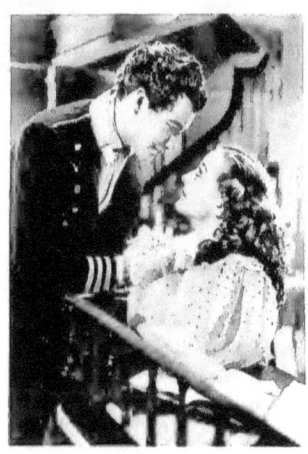

Taylor is a young naval officer in Joan Crawford's forthcoming picture, *The Gorgeous Hussy*, a story of the early 19th century

leading doctor, waved him goodbye. Some miles out of town the lad called his father on a rancher's phone.

"It's pretty far, Dad," said a childish treble. "maybe I'd better come home."

"You go on to grandmother's," said his father. And the boy finished his ride. He learned self reliance the hard way. An only son, Bob was obliged to devise his own entertainment and be self-sufficient. He is that way today—a few friends suffice. There was another advantage to his upbringing; his mother and father gave him adult companionship, and this means usually an adult-minded child who can reason with.

All of this was to help Bob over the jolts in Hollywood. He got into pictures not because he happened to be born with those clean-cut features which exemplify the American girl's dream of the American boy; he got his break playing the difficult rôle of the hard-drinking, cynical

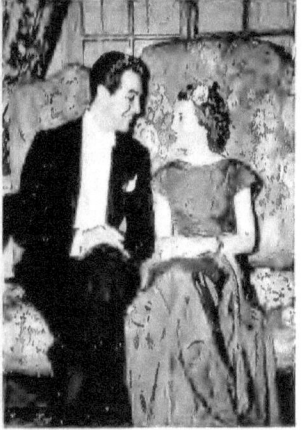

Especially wild were the rumors of a romance between Taylor and Janet Gaynor when they made *Small Town Girl*

Captain Stanhope in *Journey's End*, at the Pomona playhouse. A Metro-Goldwyn-Mayer talent scout saw the performance and he was signed.

Bob was still a greenhorn from Nebraska. He had attended college for two years at Doane, Nebraska, and then his mother decided to bring him to Pomona to finish his college education. He continued in school after signing with Metro, graduating with his degree as Bachelor of Arts.

Time went on and very little happened to further Bob's career. He began to feel as if he were the forgotten man in this huge studio. His earlier success in amateur theatricals began to seem rather insignificant to him.

Back in Nebraska, at the Paduah Hills Playhouse, he had taken the rôle of Armand in *Camille*, and done well by it. Now, he was beginning to believe, he couldn't qualify for a walk-on bit in one of these huge productions going on in the world's largest motion picture studio. Finally he took his courage in his two hands and went to see that omnipotent and mysterious figure, Louis B. Mayer. Bob asked for a release from his contract. In fact, he insisted. He intended to go to New York and try to find stage work.

A Dazzling Wardrobe Appears

● MR. MAYER shook his head. "You have a future with us," he said. "You've got grit. You've shown you can act. Maybe you've had some tough breaks so far, but we'll put you to work. Meanwhile, we'll do some campaigning for you."

Bob wasn't quite sure what that meant, but he soon learned. The studio wheels began to grind. Bob was called in and slicked up by the wardrobe department. Four good suits were added to his private collection, and Bob noticed "Okayed by

Joan Crawford Talks

"YOU HAVE TO know Bob to fully appreciate him," says Joan Crawford. And then she tells of having watched women visitors on the set watching him. They come hoping for a peek at him because he is so handsome, and to see if he is really as handsome off the screen as he is on. One look satisfies them. But after a while they discover there is more to be found out about him.

They see his easy, graceful naturalness, his thoughtfulness of others, they observe his serious workmanship before a camera, they hear his laugh, and they turn to each other and you can see their mouths forming the words, "Say, you know he's all right!"

Joan can appreciate this tinge of surprise in their attitude because she, in a way, has experienced the same thing herself. She, too, has found that there is a lot more to Bob than a beautiful hair-line, a broad pair of shoulders and a distinctive nose.

If you are one of Bob's fans you can appreciate what Joan Crawford means. There have been hundreds of letters wanting to know what Bob Taylor is really like—whether he is a swell, likeable fellow, or whether he is "just good-looking," with only good looks to recommend him. This suspicion is only natural. All beautiful heroes and heroines come in for it during the early part of their career. It's a result of the "beautiful but dumb" phrase which has been repeated for years. Not knowing Bob, one is quite apt to think: "With so many physical attributes, he can't have much else!"

We think even Joan Crawford had this attitude about him at first. We know that some time ago when Joan gave a Sunday afternoon soiree for an important musical personality, Irene Hervey, whom Bob was squiring at the time, was invited but Bob was not. Though Joan had met Bob with Irene it just never occurred to her that he would be interested in a musical

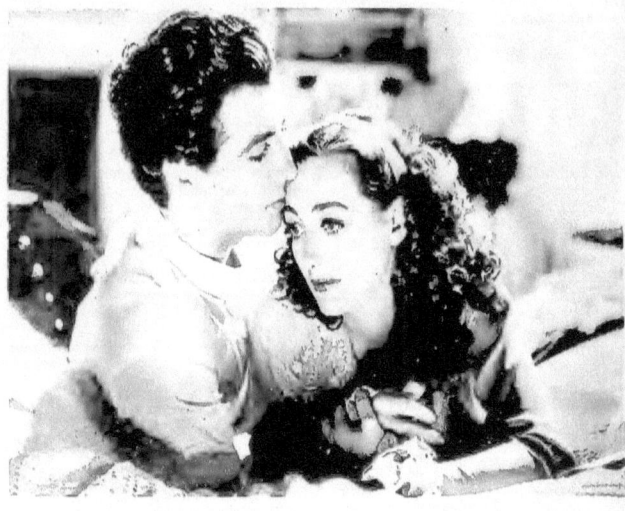

A scene like this from *Gorgeous Hussy* may arouse the envy of most fans, but after all it is just acting! Cast together in this picture, Joan and Bob became fast friends

gathering of that kind. But that was before they started working together in *The Gorgeous Hussy*. That was before Joan learned to know him as she does now. Perhaps in her "discovery" of the Bob Taylor behind the Good Looks Taylor, you'll gain a clearer picture of him too.

Joan Learns About Bob

● "THE FIRST DAY we started to work both of us were extremely nervous," Joan says. "It was my first costume picture just as it was his. Both of us were trying to adjust ourselves to our costumes and to each other."

Her first surprise came when Bob said that he didn't think he was going to like wearing costumes. "I feel too fussed up, too dressed up, too showy—you know what I mean, as though I were on parade. I don't *like* being on parade. Do I *have* to wear these sideburns?"

Bob was not pretending. We know, because since that time we have watched him at work in *His Brother's Wife*. It's a story of a doctor's struggle in the South Seas. Throughout that picture he wears a pair of slacks and a white shirt, open at the neck, sleeves rolled up. His hair is uncombed, tousled. "This is great," he said. "I don't have to keep fixing myself up!"

But since most actors do like to "fix themselves up" this revelation naturally came as a surprise to Joan and the others on *The Gorgeous Hussy* set. Point number one in Bob's favor: a boy who likes to act but who doesn't like to act like an actor.

Then there was his intense desire to please. Joan and Bob had a difficult scene together the very first day of shooting. As they took their places for a rehearsal, Bob said: "Miss Crawford, I'd appreciate it very much if you would tell me how you'd like me to play this . . . if you have any suggestions."

Startled for a moment, Joan looked at him. Then she smiled, and a memory seemed to flit across her face. "Play it just the way you feel like playing it," she said. "I know you will do it all right."

Afterwards she explained that years ago when she was making *Possessed* she had asked exactly the same question of Clarence Brown—her director then, as he

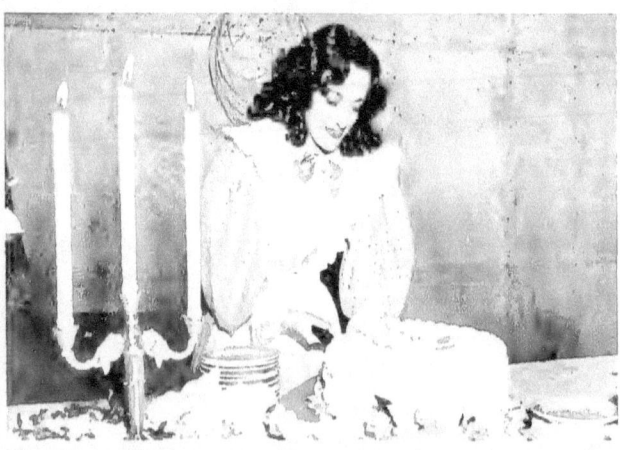

During shooting on M-G-M's picture, *Gorgeous Hussy*, Director Clarence Brown had a birthday. Joan is cutting the cake, and from the way she licks her lips, it must be grand!

About Bob Taylor!

is now in *The Gorgeous Hussy*—and that she had given Bob the same answer Brown had given her. "But I was only beginning when I asked that question," Joan added.

"You think I'm not now! You don't know what a beginner I am!" Bob retorted. "Anyway, thank you for giving me the confidence I needed."

A Sense of Balance

● THE WORLD SAYS he has "arrived." Bob says he still has much to learn ... that he's just beginning. This is what you call keeping a balance in a perilously unbalanced Hollywood.

Most of his efforts to please were less obvious and most amusing. Bob Davis, his friend and stand-in, discovered Bob in his dressing room spraying his throat with a mouth wash. "Got a cold?" Davis asked. "No, a love scene with Miss Crawford," Bob answered quickly. "She doesn't smoke very much and I do."

Anent Bob's smoking, a few days later he mentioned that he thought he'd give it up, because he wanted to gain some weight and he had heard that would help. Joan overheard him and the next morning at eleven there was a steaming milk drink at his elbow direct from Joan's little portable grill. "Your second dose comes at three!" she told him. "Go on smoking. *This* is what will do the trick! Give your Aunt Joan a chance, and she'll fatten you up. Look what she did for Franchot!"

Yet when we mentioned this to Bob he said, "Why Joan does things like that for everybody. She didn't just single me out. Did you hear what she did for Mr. Barrymore ..." and he was off on an anecdote about Lionel. Point number 3: his natural modesty.

In this respect we might also add that when Bob was talking about all the places he was going to see in New York—Grant's Tomb, the Aquarium, Central Park, the Brooklyn Bridge—someone said, "You won't have time for all that! There'll be so many women waiting to see you." Bob's only answer was "You're kidding!" He thought it *was* kidding too, until he got there and was mobbed by half the women in Manhattan.

Bob Awakens an Interest

● THEN THERE WAS the discovery of Bob's interest in music. As you know Joan always keys the moods of her scenes with music, and her phonograph is a fixed prop on every Joan Crawford set. One afternoon Joan was searching through one of her many albums—she and Franchot together have 3,200 records—for something appropriate for the next scene. She was having difficulty making a choice until Bob suggested a Brahms symphony which immediately hit the musical spot.

Joan looked at him with new interest but said nothing. The next noon when Bob, James Stewart, Melvyn Douglas and Clarence Brown returned early to the set from lunch, and they were playing some of Joan's records, they came across one which featured a soprano voice singing

There was a time when Joan Crawford did not dream she and Bob Taylor shared the same interests. Not until she played in a film with him did she learn to know and like the handsome young star

Joan Crawford Talks About Bob

an aria from Bellini's opera *Norma*. No one could place the singer. A dozen suggestions were made. Then Bob, who was listening attentively, suddenly spoke up: "You're all wrong. I recognize that voice. It's Joan Crawford's!" And he went at once to find her to make her admit it. Joan looked at him, the second time, in amazement. "How did you know? You've never heard me sing! That's one of my home recordings . . . it was in that album by mistake. How did you recognize it?"

"I recognized it because it recalled your speaking voice." And he went on to explain that while he had never studied singing, he had worked under one of the finest cellists in the country, and that had naturally developed his appreciation of tone qualities . . . to learn a distinction in instruments is the same as learning distinction in voices.

Bob Sings a Ditty

● INCIDENTALLY BOB SINGS a little ditty in *The Gorgeous Hussy*—"But not as a singer singing," he insists. "Just as a fellow having fun. I wouldn't want anybody to think I thought I had a voice. It's a goofy old sea chanty, and as such it really doesn't require any voice.

> "'If all the world were paper,
> And all the sea were ink
> If all the trees were bread and cheese,
> What would we do for drink'

"That and a couple of more verses like it is all there is to it!"

But if Bob doesn't take his singing seriously, he should at least take his dancing seriously, for he *is* a beautiful dancer. He and Joan do a Hornpipe together in the picture, but she discovered what an excellent ball room dancer he was when they took a turn or two around the set one day between scenes. And Joan isn't the only one who will attest to this Taylor prowess. Little Eleanor Whitney, who, like Joan, first won her fame dancing, says that he is one of the best she knows.

Still he never talks about any of these accomplishments. Bob Taylor is one of those people you are constantly finding things about—because you have to do literally that, find them out for yourself. He never volunteers. For example, if it hadn't been for that cooped-up butterfly in Clarence Brown's car, no one would have ever known that Bob was well schooled in entomology—the study of insects, to you!

Joan says that she discovered the butterfly on Clarence Brown's steering wheel, and thought it was so beautiful that she caught it in her hat, to examine it closer. She was just about to call the museum and try to find out what species it was when Bob came along. "Oh, that's a Tatilio Terganus," he said. "Or sometimes it's called Edward's Swallowtail. They're quite rare . . . bring $7.50 a pair." Joan realizes that it's a small point, but indicative. Bob has a keen knowledge on many such interesting subjects.

Supper at Joan's House

● NATURALLY YOU CAN see where all this was leading to . . . direct to a Sunday evening supper at Joan Crawford's house . . . where Bob went one evening with Barbara Stanwyck. Barbara and Joan have been good friends for years. When Joan was married to Doug Fairbanks, Jr., Barbara and Frank Fay lived right across the street, so they're really neighbors of long standing. But it wasn't because Bob is now best beau to Barbara that he was invited to Joan's. It was because Bob was Bob and because Joan wanted his friendship.

That is the greatest recommendation anyone can have in Hollywood for, as you know, all Joan's friends have something distinctive about them. They are all busy, doing-things people. They are all "important" people, not in a business or social sense, but important of themselves, because they are worthwhile.

Joan pays her own tribute in this way: "I find Bob most considerate and wholly unconscious of his growing popularity. Working with him has been delightful and I should love to make another picture with him. My only regret is that he didn't have a bigger rôle in the picture. His part is small but rather than turn it down he said that he welcomed the experience he would gain from it. The only way I feel I can pay him back is by playing leading lady to him. Which I will look forward to doing some day!"

That, from Joan Crawford, is a lot!

LETTER CONTEST

Win Bob Taylor's Monogrammed Prize

Bob Taylor offers a monogrammed prize in this month's contest! We can't reveal the nature of the valuable prize until we know whether the winner is a man or a woman!

Win Bob Taylor's Prize

As a special requirement for this month's contest, the editor adds this stipulation: along with your letter name your ten favorite film stars in the order of your rating. HOLLYWOOD Magazine wants this information so it may more readily meet the public taste in articles appearing in future issues.

Here are the rules:
1. Write your letter in either pen and ink or on the typewriter. Legibility, neatness and conciseness count.
2. Make your letter brief. There is no set limit to the length of HOLLYWOOD's letters, but the editor reserves the right to strike out portions deemed unnecessary. Brief letters win more favorable consideration.
3. Your letter must be interesting. Will it lend itself to comment from the editor? Are there two sides to what you have to say? Is it really worth saying? These are tests that will improve your letter.
4. List the names of your ten favorites, in the order of their standing, on the sheet printed below. Attach or enclose this in your letter. (Be honest with your choices—they have nothing whatever to do with the letter contest and are for polling purposes only.)
5. Address your letter to HOLLYWOOD Magazine, Dept. BT, 7046 Hollywood Blvd., Hollywood, Calif. It must arrive here not later than December 10. No return correspondence can be attempted. The judge's decision is final.

How WOULD YOU like to own a valuable prize bearing Bob Taylor's own monogram? HOLLYWOOD Magazine offers just such an award this month to some lucky writer who submits the best letter to the editor this month! Read the rules carefully and then join in the contest. Even if you lose you may be one of many writers who will receive a dollar bill for having a letter published!

HOLLYWOOD Magazine wants interesting, stimulating and concise letters from its readers. To accomplish this purpose and improve the general quality of the letters, the editor joins with M-G-M and Bob Taylor in this contest offer.

Write your letters about anything related to the motion picture world. Perhaps there is something you would like to see on the screen, or in this magazine that hasn't been suggested before. You may have a comment about your favorite star—or an actor you don't like! Whatever it is, HOLLYWOOD wants to know what is in the minds of its readers!

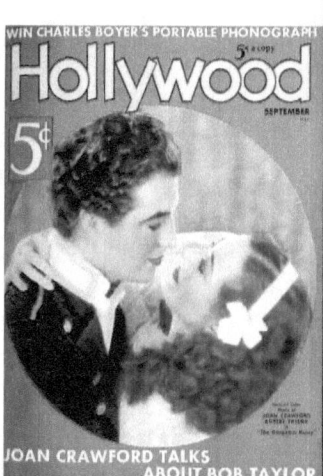

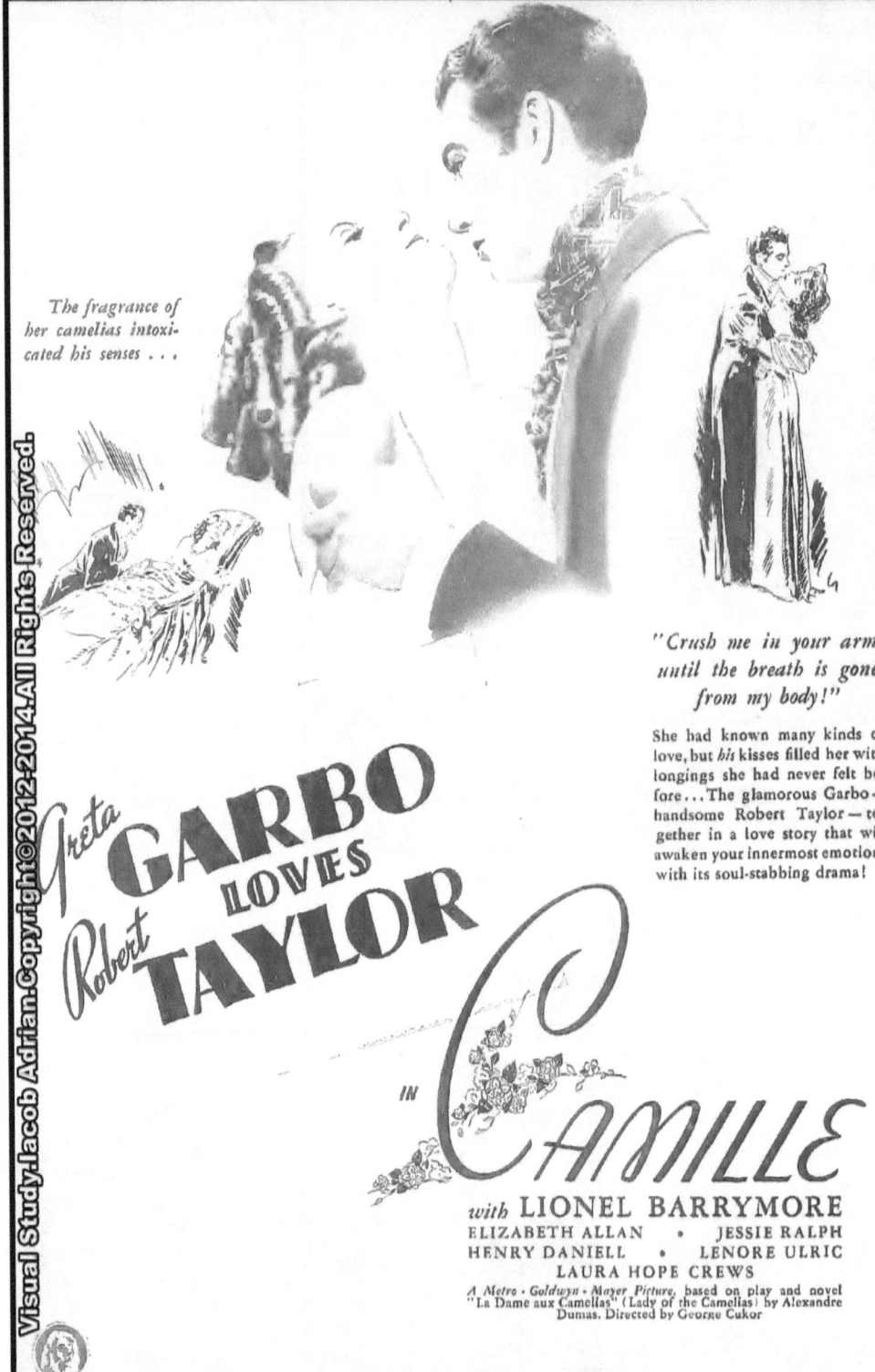

Shrine Fezzes Corner Bob Taylor On Set!

By Hamm Beall

YOUR HOLLYWOOD CORRESPONDENT not long ago, as the photo on this page will bear witness, was accorded a privilege that probably thousands of feminine film fans would have sold their chances of playing an alto harp in St. Peter's Celestial Orchestra to enjoy, namely being photographed with Robert Taylor right on a set at Metro-Goldwyn-Mayer's monumental movie manufactory at Culver City, a southwesterly suburb of Hollywood.

It was my first meeting with the reigning masculine favorite of 1936 and 1937 despite the fact that thousands of letters had reached my desk as managing editor of this cinema chronicle, each and every epistle exuding enthusiasm over the charm and Thespic achievements of the young Pomona College graduate, whose *Armand* to Garbo's *Camille* probably is giving even Alexander Dumas a thrill regardless of the destination to which he was delivered by Charon, chief ferryman of the River Styx.

If the reader, the reader's father, husband, brother or son happens to be a Mason, it will be appreciated that when I took Judge Clyde I. Webster, of Detroit, Imperial Potentate of the Shrine of North America to M-G-M, your humble scribe was armed with an open sesame of potency

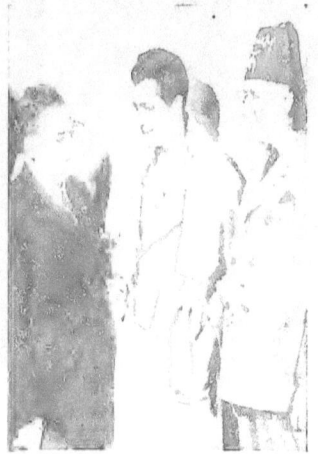

Hamm Beall escorts Judge Clyde I. Webster, of Detroit, Imperial Potentate of Shrine, to M-G-M studios to meet Robert Taylor

equal to that used to obtain entrance to the cave of Ali Baba and the Forty Thieves.

"The wife would never forgive me if she heard I came to Hollywood and did not meet Bob Taylor," the head man of the crimson-fezzed nobles whispered in my ear as soon as he heard that Jean Harlow

and Taylor were starting *The Man in Possession*, and when Lawrence Cobb, potentate of Al Malaikah temple, learned that Woody Van Dyke was directing the picture that Douglas Fairbanks, Jr., made famous as a stage play, the Los Angeles Shrine chieftain started the party in a bee line for Stage 6. Woody received the ancient Arabic ritual of the Shrine a few months ago and when his potentate appears it's just a case of dropping everything else and concentrating on a certain amount of Grade A salaams.

Woody was most gracious and so was Bob, particularly when he found out that I, too, was an old Pomona College student, if you use the word student advisedly. Of course, the fact that I was a Fawcett editor did not mitigate against me.

Jean Harlow was not scheduled for the scenes shot that day, but had just paid a social visit to the set a few minutes before, and Hugh Caldwell, past potentate of Nile Temple, Seattle, was rather disappointed.

Bob was in a swank bathrobe and had just been catching the very devil from his father and brother for having disgraced the British family name by serving a sentence in an English reformatory. This angle, and the fact that later on in the story he has a job as a bailiff to take possession over attached property, particularly interested the Shrine national leader, for it was in line with the legal lore associated with Judge Webster's courtroom in the motor metropolis.

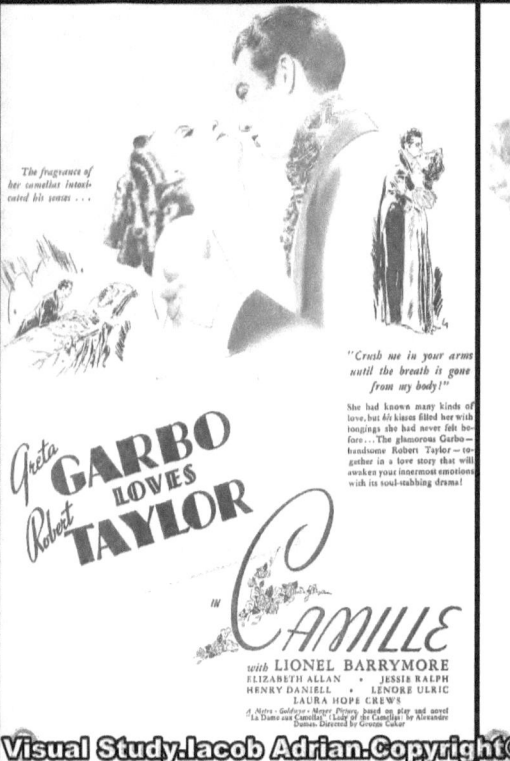

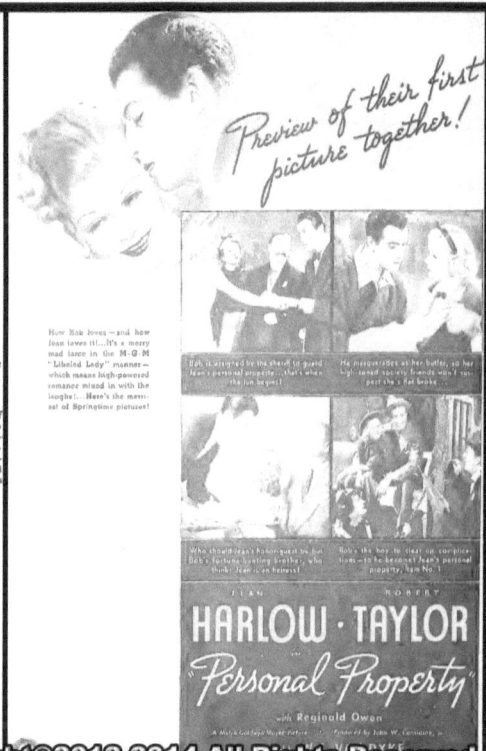

JEAN HARLOW AND ROBERT TAYLOR

Rumors say the reel romance of this pair in *Man In Possession* is real, but the truth is Bob is true to his Barbara and Jean to her Bill

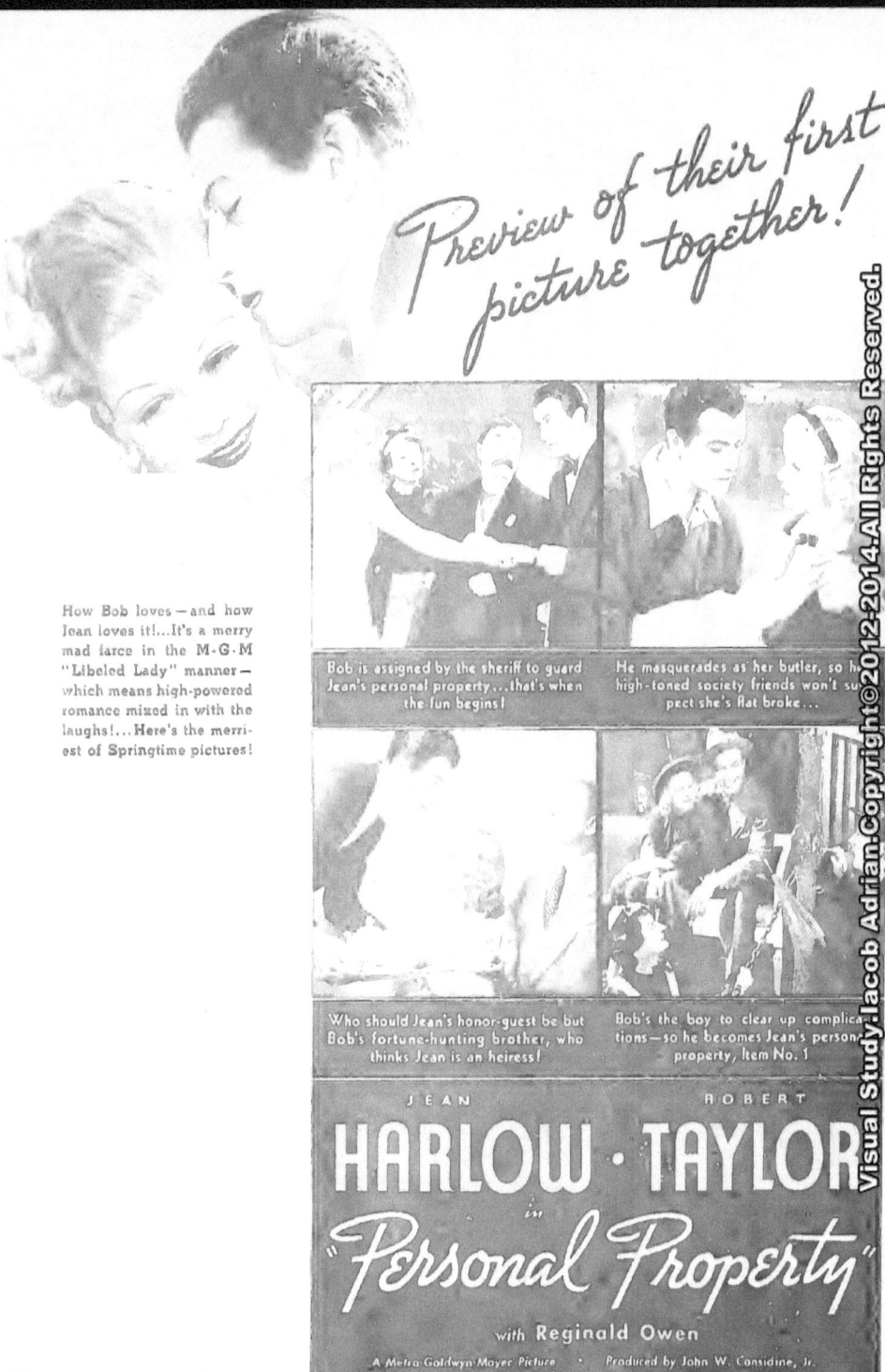

THE GAY LIFE OF HOLLYWOOD BACHELORS

By LEON SURMELIAN

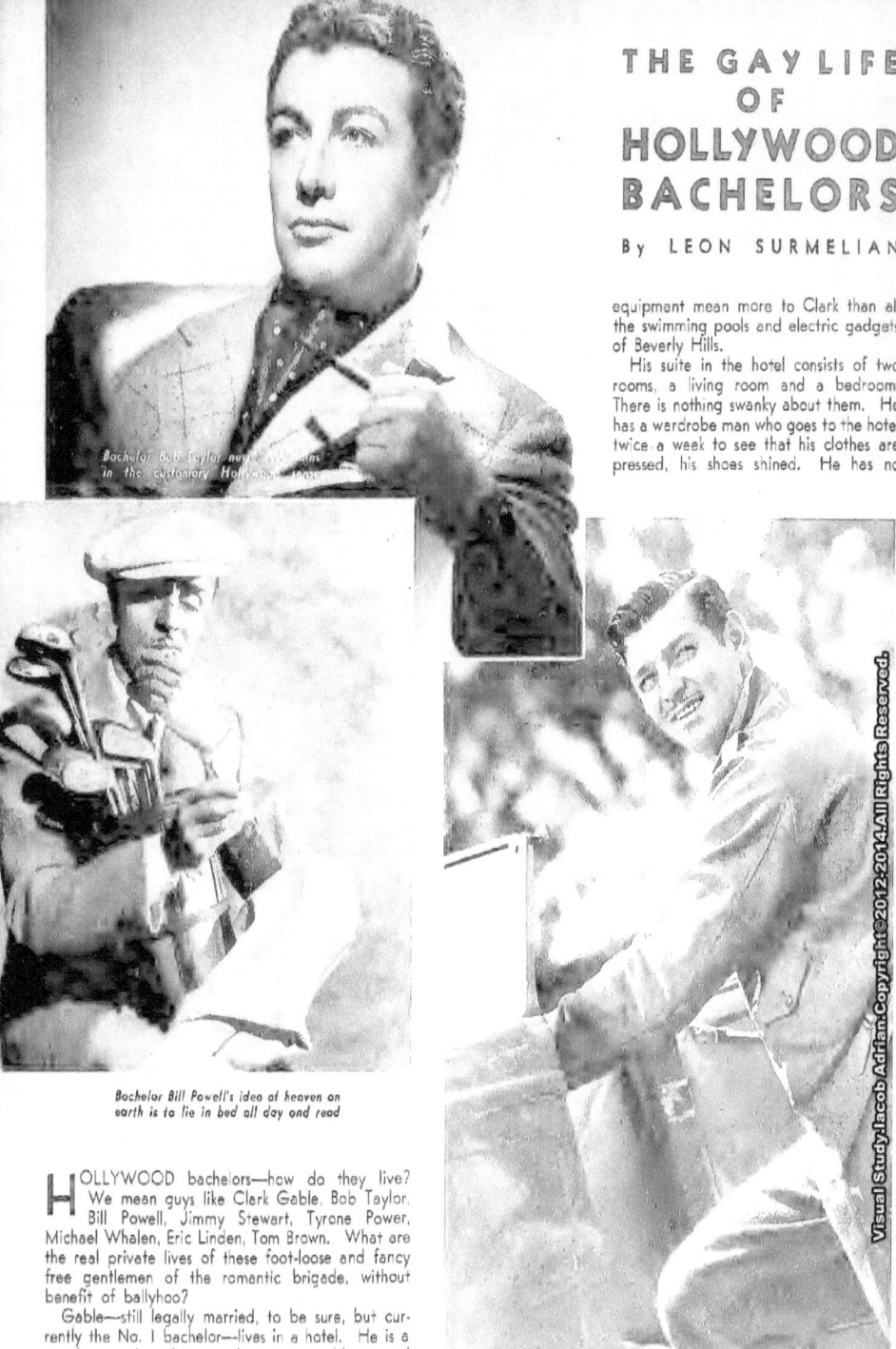

Bachelor Bob Taylor never indulges in the customary Hollywood orgies

Bachelor Bill Powell's idea of heaven on earth is to lie in bed all day and read

Bachelor Clark Gable's idea of a party is to talk and play cards with two or three couples in the home of a friend

HOLLYWOOD bachelors—how do they live? We mean guys like Clark Gable, Bob Taylor, Bill Powell, Jimmy Stewart, Tyrone Power, Michael Whalen, Eric Linden, Tom Brown. What are the real private lives of these foot-loose and fancy free gentlemen of the romantic brigade, without benefit of ballyhoo?

Gable—still legally married, to be sure, but currently the No. 1 bachelor—lives in a hotel. He is a wanderer and outdoor man by nature, and home and property don't mean very much to him. "I like to live under my hat," he told us. "My Hollywood mansion is my station wagon." Hunting and fishing equipment mean more to Clark than all the swimming pools and electric gadgets of Beverly Hills.

His suite in the hotel consists of two rooms, a living room and a bedroom. There is nothing swanky about them. He has a wardrobe man who goes to the hotel twice a week to see that his clothes are pressed, his shoes shined. He has no

JULY, 1937

The Gay Life of Hollywood Bachelors

secretary, no servants. "I eat out all the time. For breakfast, usually I have a baked apple, cereal, coffee and toast. For lunch, a sandwich or two, maybe a salad. But I go to town for dinner. I have no favorite place to eat. When I am working, I lunch at the studio commissary."

You never see Clark Gable in Hollywood's celebrated night clubs, and he doesn't care to dance. "My idea of a swell Saturday night party is to talk and play cards with two or three couples in the home of a friend." He never entertains. Sometimes he takes a few people out to dinner, that's all.

Bob Taylor lives in a small, one-story house on a quiet street in Beverly Hills. He has a Hungarian servant, Joe. There is absolutely nothing about this place to indicate that a movie star lives there except the long arrays of suits in the closets and the stacks of freshly laundered shirts which Joe has a habit of piling up on beds and dressers. The living room, with its radio, books, fireplace and tricky little bar is such as any successful bachelor living alone might have. He sleeps in a small bedroom, almost austere in its simplicity. There is a guest room, a small gymnasium, bathroom and kitchen, all neat and spotless, but innocent of the arts of professional interior decoration. "I've taken another year's lease on this house," Bob said proudly. "I like it."

Bob loves to dance, anywhere where there is a good orchestra. He never entertains in the customary Hollywood sense. Now and then he takes a few friends to the Beverly Wilshire Hotel for a dinner dance.

BILL POWELL gave up his famous palazzo in an ultra-ultra section of the movie colony, apparently because he was tired of living like a lone emperor. His present house, a good-sized one, but far from being a palace, is located in the comparatively plebeian atmosphere of West Los Angeles. Instead of holding open house, he holds open court—for tennis players. He likes to entertain informally. He has a barbecue pit, and after the feast runs off a picture in his projection room.

"I'd rather have my friends come to my house than go out myself," he said.

Bill Powell has devoured a good-sized library. His idea of heaven on earth is to rest in bed all day and read. "I'm terribly lazy. If I ever build a swimming pool again, I'll have a moat dug around my house and swim round and round without the necessity of turning back after a few strokes. I think I'll also have a drawbridge."

James Stewart lives in Beverly Hills, with Joshua Logan and John Swope, two young men who are interested in the directorial and production end of motion pictures. A fourth member of this gang was Henry Fonda, now sane and married. "We had a swell house in Brentwood," Jimmy said, "but when Fonda got married we moved to a much smaller place and kept looking for another house. We had to wait another month before we found a house we liked.

"Before I came out here," continued Jimmy, "I had an idea that this was a wild town of Babylonian whoopee parties, that nobody came out of Hollywood unsinged, that by signing a movie contract you signed your death warrant, and all that stuff. Who gives those whoopee parties, I'd like to know! Why, this is the quietest town I have ever lived in, and I have never met so many nice, well-behaved people in my life."

Jimmy would like to marry and build a home of his own, "on a hill," as he explained. Remember that he studied architecture at Princeton. We were curious to know why he doesn't have a steady girl, why he steps out now with Eleanor Powell, now with Ginger Rogers or Virginia Bruce, and keeps the movie snoopers guessing. The color deepened in his cheeks. "I'm wondering, myself, why I don't have a special girl! In college, I usually went to the proms stag. I used to take girls to proms and house parties, but for some reason or other they were always whisked away from me." Jimmy doesn't seem to realize how popular he really is with the lovely peaches of Beverly Hills.

THE other day we lunched with Tyrone Power at the 20th-Century-Fox Studio. This slender, patrician six-footer with glittering dark eyes is a vital and vibrant chap, full of the joy of life, and are the gals crazy about him.

"I live with my mother in a little house," he said. "Our house isn't large enough to accommodate a lot of people, so I give only small dinner parties, or more often, go outside. I stay in two nights a week, to write letters and attend to business affairs. When I'm not working I like to go to Palm Springs. My hobbies are tennis, bowling and swimming. Most of my friends are non-professionals."

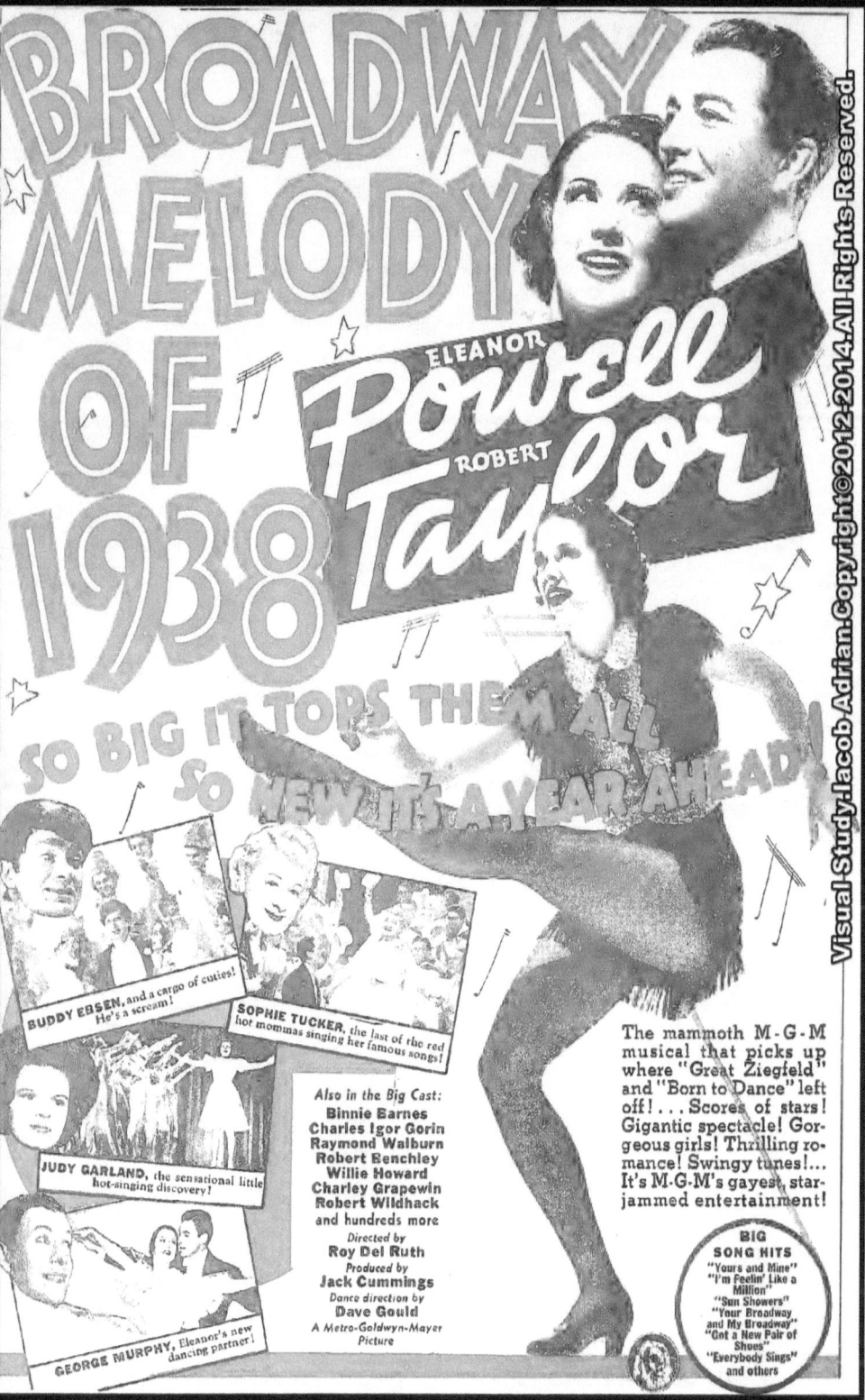

"I'LL NEVER RETIRE"

SAYS
ROBERT TAYLOR

TO
VIRGINIA WOOD

The screen's greatest attraction since days of Rudolph Valentino and Wallace Reid emphatically spikes all rumors he's ready to quit pictures

WE HAD heard that Robert Taylor planned to retire. We had heard that Robert Taylor did not plan to retire. We had heard that he was contemplating resuming his study of medicine so he could follow in his father's footsteps. We had even heard that he had set a time limit for his retirement—five years. And we had heard that it was all a lot of poppycock and that he'd never give up the screen.

So we went out to Metro to talk to him about it.

"I don't know where all these rumors come from," Bob told us, shaking his head sadly. "In the first place, I'm tied up to a contract which doesn't expire for seven years. In the second place, I loathe and despise medicine. Never did like it. Science and physics and all that sort of thing bored me to death. The only reason I went in for it was because my father was a doctor and I thought I could take over his practice. It's the last thing in the world I'd ever want to do—now."

"Why 'now'?" I wanted to know.

"Oh — you know — after being an actor." Bob lit a cigarette. "It's really the most exciting business in the world," he went on, meditatively. "There's something stimulating about the constant changes and activity on a studio lot that is hard to explain. I come over here all the time when I'm not working, just to see what's going on. It's fascinating—much more so than Hollywood swimming pools and tennis courts. For that matter, I find that there's nothing more relaxing than watching other people slave away while you loaf and murmur gentle little encouragements."

"Don't you ever have a desire to go on the stage?" I asked.

"Nope!" he said, emphatically. "Don't think I'm a good enough actor." He laughed. "Why, they'd boo me off the stage in a really high-class show. I wouldn't have a chance!"

Which was really something, coming from the lips of the screen's greatest attraction since the days of Rudolph Valentino and Wallace Reid!

"Would you live in Hollywood if you weren't in pictures?" we persisted.

"Nope!" he answered, emphatically, "I'd get me a ranch some place. Maybe in Northern California or Wyoming or some place like that. I like the seasons. You know—winter, spring, fall—the sort of thing you don't get here."

"What would you have on the ranch?" I queried.

"Oh—cattle, dogs, horses. Mostly horses, I guess. The thing is, I don't like city life much. Don't care about night clubs, parties—that hey-hey stuff."

"Haven't you any hobbies?"

"Nope. I don't do any of the things I'm supposed to do. I like to take trips in the car—and ride. That's about all I do."

At this point, we had a very definite idea things weren't working out as they should be. We had a distinct feeling that this Bob Taylor we'd been hearing about—the matinee idol, the high-hat individual who considered himself so important he kept quite aloof from the common herd—was not running true to form.

"But don't you want to travel—or do any of the things screen stars are supposed to want to do?" we insisted.

"Sure. There are a lot of things I want to do—but not now."

WE BEGAN to realize that Bob is just a little bit scared of the position he's in at the moment. He can't for the life of him understand why people make such a fuss over him. He doesn't want people to make a fuss over him, what's more.

We also discovered that the reason he only spent a day and a half in Honolulu when he went there recently, on a long-anticipated trip, was because he found himself so deluged with invitations to do a lot of things he didn't want to do that he wasn't going to have time to explore any of the out-of-the-way spots he'd been dying to see. Instead of seeing things, it was reversed. He was being seen.

"The studio is sending me to England pretty soon. I told them I wouldn't go unless I could live in the country. I can't stand the idea of living in London or any other metropolis." Bob laughed. "Of course they'd probably have sent me anyway, no matter what I said, but I thought I might as well ask. They said okay."

We were suddenly aware that this Bob Taylor was a pretty miserable sort of fellow. In fact, Bob has found himself in the unenviable position of being a small town

"I'll Never Retire"
[Continued from page 28]

boy turned loose in a most sophisticated environment and not liking it at all.

"You know," he said, "it's the hardest thing to explain, all this fuss. People are so darned kind to you, everywhere you go. And it isn't that I don't appreciate it. I'd probably be awfully sore if they weren't. But sometimes a guy feels like he just has to cut loose and do at least some of the things he wants to do in the way he wants to do them. Half the time you can't be yourself for fear of hurting someone's feelings."

AT THIS moment, the assistant director called Bob away to the set. Things hadn't been going so well that day. One of the actors had been having difficulty in getting his lines right. So far, they'd tried at least ten times to get one scene. He came back presently and flopped down in an easy chair.

"Tell me," we asked, "Do you act mostly because you want to act, or for what you'll be able to get out of it materially?"

He grinned.

"So that's what you've been getting at—a barb in every interview! Okay—here's your answer!

"Both! I like acting better than any other profession. But like everything else, you have to take the bad with the good. In my case, the bad part of it is all this celebrity business—having to be an actor twenty-four hours a day. In most other jobs, you put in your eight hours a day and then quit being a bookkeeper and start being yourself. In Hollywood, you can't do that.

"So my plan is that when I've run out of parts that I can play—I'm not good enough to be a character man, you know—I'll retire to that blessed anonymity, raise my live-stock on whatever I've been able to save out of the material proceeds of the game and then start traveling about on the balance.

"And then will I have the fun! I'll be one of the guys that does the staring. I'll be able to rubber all I want to. I'll take snap-shots of my fellow man, the leaning tower of Pisa and the surf-boarders at Waikiki."

He fished in his pocket for a bit of paper.

"Please, Ma'am—c'n I have your autograph?"

And right then and there we got the idea that the interview was over!

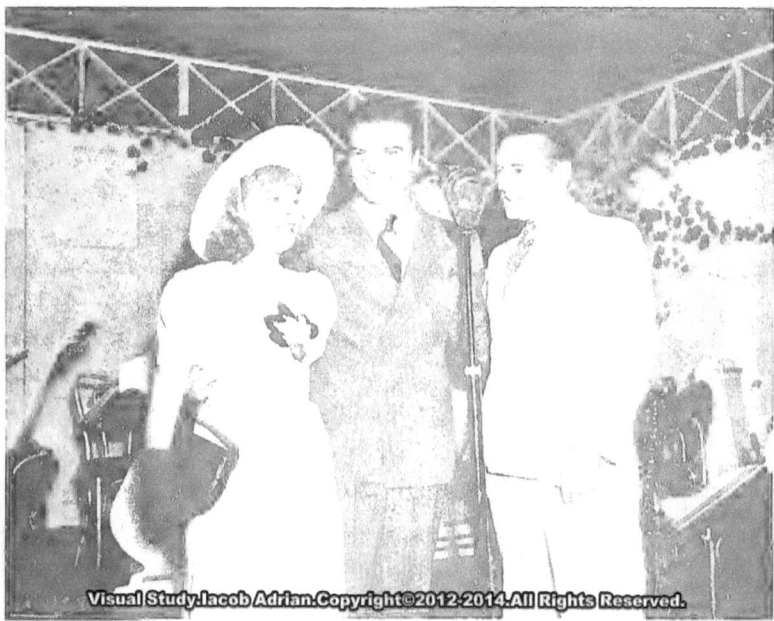

Among the screen celebrities who attended the Fawcett Movieland Tours supper dance at the Wilshire Bowl were Craig Reynolds and Gertrude Niesen. Jimmie Fidler, radio commentator, is shown introducing them to the guests

Hollywood

A FAWCETT PUBLICATION

NSC

JANUARY

5¢

ROBERT TAYLOR

TRY THE FASCINATING FILMLAND NEWS TEST

THE HARRIED CHEST

No matter what is revealed to the eyes of a waiting world, if and when Robert Taylor takes up the challenge of the inquiring reporters, this story springs to his defense by saying "So what?"

Many a kind heart beats beneath a home-grown chest-protector

By ALMA WHITAKER

When a bunch of reporters, jealous of Robert Taylor's admiring feminine legions, taunted him into saying he would bare his bosom for public exhibition "of the hair that grows thereon," screen idols began inspecting their chests anxiously.

Especially, don't you know, as he-man authors Ernest Hemingway and Max Eastman had likewise been indulging a hairy-chest controversy.

All of Hollywood is involved in the argument.

Because, you see, such indubitably he-men as Errol Flynn, Victor McLaglen, Tyrone Power, Charles Boyer, Leslie Howard, Mischa Auer, Andy Devine, yea, and even Buck Jones, can boast the merest trace of downy chest adornment.

Still Gary Cooper, Joel McCrea, David Niven, Randolph Scott, Fred MacMurray, Clark Gable, Dick Powell, Pat O'Brien, Edward G. Robinson, John Boles and John Beal are prepared to match Robert Taylor's hairy bosom any day. Cary Grant has enough to pinch.

Peter Lorre seems to be tops in the field with a regular doormat, even superior to the Tarzans, Johnny Weismuller and Glenn Morris. Both Laurel and Hardy play him a close second, and so does Woolsey (the while Wheeler hangs his head). Don Ameche, Brian Donlevy and Tony Martin can make a pretty good showing.

So far so good. But hairy evidence can be pretty unreliable. For instance, this famous Lou Gehrig, "iron man" of baseball, who has just come to Hollywood for immortalization on the screen, hasn't a hair on his bosom. Yet Roland Young, who rather specializes in masculine timidity on the screen, can boast a marvelous doggy array. In fact, so evident is Roland Young's that when he took that shower in *Topper*, the Hayes office insisted upon the cameras being so arranged that no brush would be visible. And wasn't it Tony Moreno who had to shave his chest for *Bohemian Girl*? Certainly Doug Fairbanks had to shave his for the

And many a muscle-man gets sunburned on the chest

Thief of Bagdad. Other distinctly hairy guys are Eddie Cantor, Joe Penner, Parkyakarkus, and Eric Blore. (Eric, oh dear, who shines so conspicuously in cringing roles!)

Voilà, sisters, draw your own conclusions. Nevertheless, so firm is tradition, that you'll be well-advised to assume that your gentlemen friends have hairy chests. There is even a firm in Hollywood that undertakes to supply chest toupees for such males as must play tough-guy roles. The subject teems with interest, since there are blond and brunette bosoms, curly and straight-haired bosoms, downy or wiry bosoms, spotty or carpeted bosoms. And they all love to show 'em at the beach, which is why trunks came in and bathing suits went out.

Yankee Squire

When Robert Taylor was in England making *A Yank at Oxford*, he lived in a fifteenth century farmhouse near High Wycombe, Buckinghamshire, and, when he was not busy at the studio, enjoyed the life of a country squire. Here are some of the pictures he brought back. At the top of the page you see him in cap and gown which he wears in his British film. 1. One of the thoroughbreds from his rented stables seems to be making a confidential request. 2. What do you want? An autograph? 3. Oh, you want a spot of oats! 4. Hey, one at a time! 5. Off for an early ride before reporting to the studio

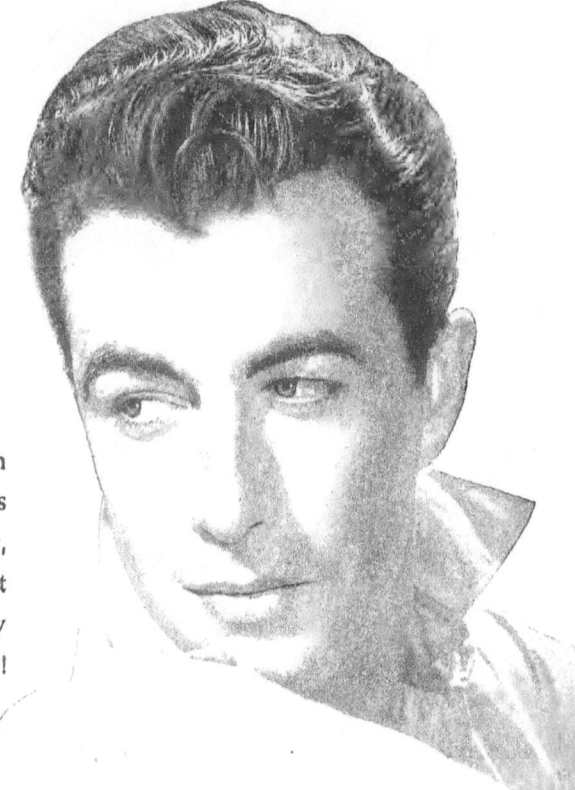

Two-fisted American college student goes to Oxford! Oh, boy, here's a drama that packs a wallop every minute of the way!

Robert Taylor
in
A YANK AT OXFORD

with **LIONEL BARRYMORE**
Maureen O'Sullivan • Vivien Leigh
Edmund Gwenn • Griffith Jones • From an Original Story by John Monk Saunders
Directed by JACK CONWAY • Produced by MICHAEL BALCON
A METRO-GOLDWYN-MAYER PICTURE

...Torn from a million souls

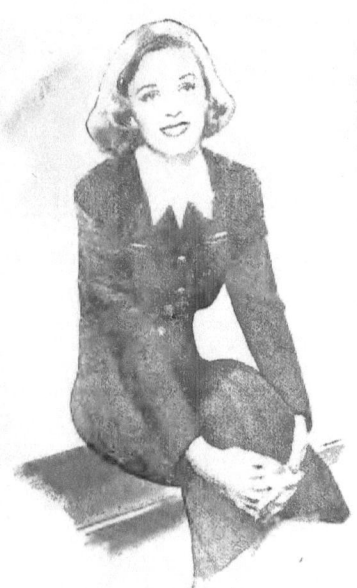
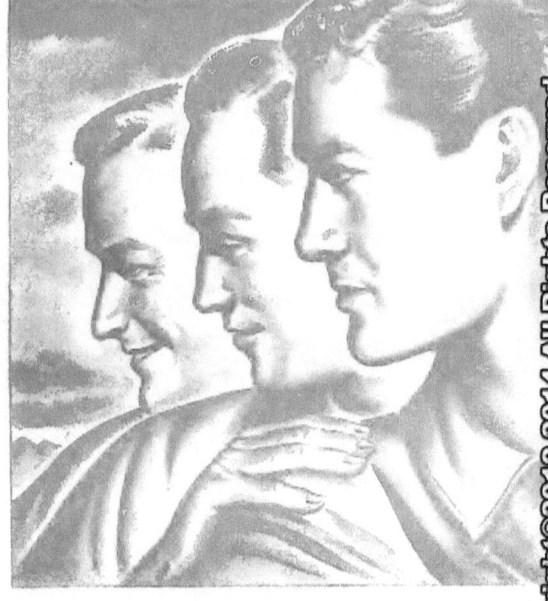

Out of the inferno of war came three men and a woman — to live their lives, to strive for happiness, to seek love... The most heart-touching romance of our time, brilliantly re-created upon the screen, from the world-renowned novel by the author of "All Quiet on the Western Front".

ROBERT **TAYLOR** MARGARET **SULLAVAN**
FRANCHOT **TONE** ROBERT **YOUNG**

in Metro-Goldwyn-Mayer's Vivid Drama of Today

Three Comrades

with **GUY KIBBEE • LIONEL ATWILL • HENRY HULL**
A FRANK BORZAGE Production • A Metro-Goldwyn-Mayer Picture
Directed by FRANK BORZAGE • Produced by Joseph L. Mankiewicz
Screenplay by F. Scott Fitzgerald and Edward E. Paramore

A FRIEND CALLS JOAN CRAWFORD "CRAZY"

Hollywood

A FAWCETT PUBLICATION

JULY
N5C

5¢

ARE THE
"THREE COMRADES"
GOOD FRIENDS
OFF STAGE?
STORY ON PAGE 23

On the screen, they think and act with one purpose. How do they differ, once the spotlights are dimmed and the camera runs down?

Smiling at Margaret Sullavan, who has the leading woman's role in their new film, are the Three Comrades, who are interestingly contrasted in this story, Robert Young, Franchot Tone and Robert Taylor

Three Comrades
ON THE SCREEN——AND OFF

By SONIA LEE

■ "Reloading," the cameraman chanted.

The brilliant lights winked off. For a brief moment the tension on the set relaxed. Property men lighted cigarettes. Director Frank Borzage consulted his script clerk. There was a buzz of talk.

The three principals walked to their name-marked canvas chairs for that welcome interlude of rest. They sat close together—these three—Robert Taylor, Franchot Tone and Robert Young, the illusion of their parts in *Three Comrades* still on them. In their eyes and attitude lingered the spiritual comradeship of the tale which they were bringing to life for the screen.

Three Comrades, by Erich Maria Remarque, author of *All Quiet on the Western Front*, is the touching story of three men who together have tasted the bitterness of War. Who together are caught in the maelstrom of post-war adjustment, with its bitterness and cruelty and disillusion. Caught like straws in the unrest and instability of war's aftermath!

The only faith the three comrades have is in each other, in the understanding which binds them together and gives them enough strength to live and love—and die!

This is the epic theme, and events serve only to embroider it. The story itself is fairly simple. The three are owners of a small automobile repair shop, where Franchot Tone has built a phenomenally fast racing car. Robert Taylor meets and marries a girl with the mark of death on her. To give her needed hospital care, Franchot sells the love of his life—his car. Bob Young, active in a patriotic group, is killed in street rioting.

Franchot and Taylor revenge his death. Taylor's wife (Margaret Sullavan) dies.

And so Robert Taylor and Franchot Tone are left to face the uncertain future together—comrades!

Off the screen, the two Bobs and Franchot are friends, certainly, but with none of the deep and thrilling comradeship which they must portray on the screen.

It is a tribute to the individual abilities of Taylor, Tone and Young, that on the screen they create the illusion of being products of the same world, the same thought, and the same troubled times, with similar backgrounds and experiences.

They play their parts with tenderness and integrity. They make the story unfold vividly and brilliantly. They make of friendship a tangible thing. They ARE three comrades, as alike as carbon copies.

■ But in reality, Franchot and Robert Taylor and Bob Young are distinctly different. In fact, they are representatives rather of distinctive types in Hollywood.

Tone—the idealist, the man with the philosophical turn of mind; the cultured product of New England, whose reserve and balance has not been lessened by Fame and Fortune.

Robert Taylor—the Horatio Alger hero, if there ever was one. A youngster who achieved world adulation overnight, became king of a million feminine hearts, but still retained the liking and respect of the men who know him.

And Robert Young—the enthusiastic

Three Comrades On The Screen—And Off

lad to whom Fame came slowly; who worked for what he has achieved over a period of years, who is similar in many respects to ambitious men his age in every walk of life.

■ By the very nature of his character, Hollywood knows Franchot least of these three. He is sensitive and intuitive. He is not one of those hale and hearty individuals who slaps a person on the back on short acquaintance, tells the story of his life, or reveals his cherished thoughts at the drop of a hat.

As a matter of fact, his sole complaint about the business of being an actor is that the private affairs of a player become the property of the world at large. The one thing which made his courtship of Joan Crawford less than ideal was the minute report of its progress in the public press.

His circle of intimates is small. Robert Taylor and Barbara Stanwyck are frequently on the guest list of those attending the charming dinners given by Mr. and Mrs. Franchot Tone, when they entertain a famous musician, a world-renowned savant, or others who have won distinction outside the Hollywood world.

With the exception of the reception Joan and Franchot gave for Leopold Stokowski, they have never entertained on a large scale. That is in keeping with the graceful, gracious background which is Franchot's. Son of an important figure in America's business world, his childhood was serene, his education comprehensive.

He attended private schools here and abroad. He had tutors during the time when family travels made school attendance impossible. He is a graduate of Cornell University. He has been awarded the Phi Beta Kappa key—the mark of scholastic excellence.

Franchot Tone is serious and studious—with deep, untapped wells of reserve. He makes friendships slowly, but once his allegiance is given, it is lasting and loyal.

Few know him, for he is not an easy person to know well. But his brilliant mind, his deep understanding of human nature, his fine artistry as an actor have achieved for him a deep respect in Hollywood, which is unmixed by envy or resentment.

His interests are wide. Books, the progress of the theatre, music, new trends in thought and world events, engage his attention. He takes his life and his work seriously, but not himself.

■ The meteoric rise of Robert Taylor has obscured to some extent, his worth as a fine person. It has interfered with

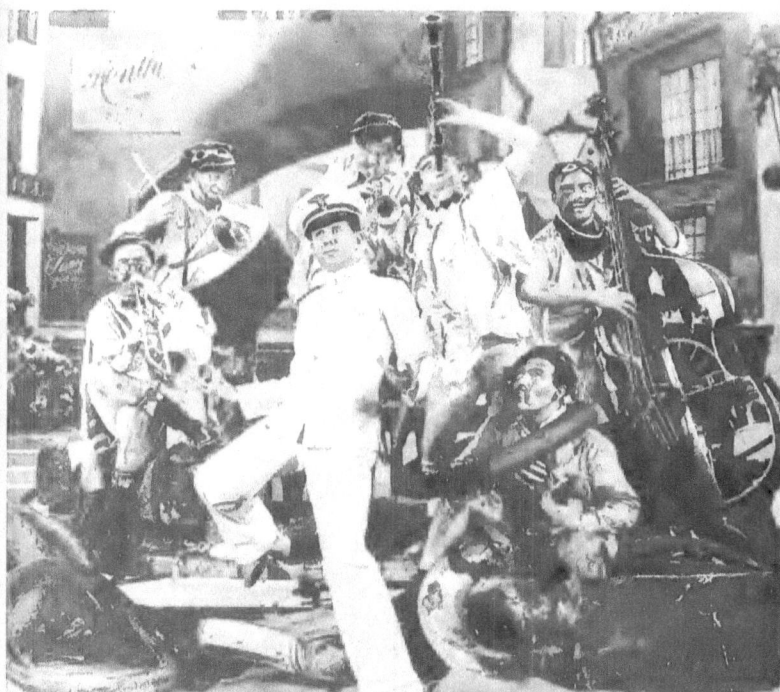

Rudy Vallee and the Schnickelfritz Band join in some violent melody. You'll see them in *Golddiggers in Paris* in even madder activities than this

the honest appraisal of him not only by the world at large, but even by a few in Hollywood.

As the calendar tells the story, he is very young—just about the age when the average young man is getting his first foothold on the rungs of the success ladder.

Taylor reached the top instantly through the force and pulling-power of personality. The world has given him Fame—but nevertheless has been unfair to him. It has forced him into a manufactured shell as protection against unjust barbs, criticism without basis, and a watchfulness of his every action which is an emotional load for any one to carry.

I remember Bob Taylor before this burden called Fame came to him. He was gay, carefree, ambitious. He had a refreshing frankness. He was a wholesome boy, just out of college, hopeful of the future, eager to make friends, to be liked. He was YOUNG.

There were no hidden places in his personality. He was a worthy product of substantial, middle-western Americanisms. His life has been well-ordered. Son of a physician, he has the average number of advantages—music lessons, school activities, college, all well-balanced by the stiffening influence of vacation jobs, a sense of responsibility to himself and his heritage.

His becoming an actor, as you know, was an accident—the result of being seen in a school play by a studio scout, who took Bob's mind away from his planned profession of medicine and bent it to the exciting life of acting.

Fame is a responsibility, make no mistake about that. Robert Taylor has paid a considerable price for his prestige. He has learned many a bitter lesson through it. That there is injustice and envy. That a man can be helpless even with a world at his feet.

It has sobered Bob. It has taught him to spot lip-service. It has taught him to limit his spontaneous desire to be friends with everyone. And it has taught him that frankness can be a boomerang. In self-protection, he has become reserved.

Not since Valentino has anyone been subjected to such a vicious, malicious attack as Robert Taylor has been. If his eyes are a little tired, if he is older than he should be, there is ample reason for it.

And so the Bob Taylor that Hollywood first knew—the boy so eager to live life fully, to meet and know people, to be seen everywhere, has given place to a man who is quieter, far more self-assured, with an active sense of what is reality and what is illusion.

He differs from Franchot in that what he is, he became quickly, and so is representative of all of Hollywood's skyrockets. He differs from Bob Young in that he learned everything in the pitiless and merciless glare of a spotlight, rather than in the comfortable twilight of a career built step by step.

■ The third comrade, Robert Young, is the essence of the new Hollywood, which works hard, lives unostentatiously but normally, which is interested in the multiple, small concerns of everyday life.

Unlike Franchot and Taylor, Bob did not have the advantages of advanced education, of ample funds, of a well-set plan of life. His talents indicated that his place was in the theatre. But his own and his family's need again and again forced his feet into other occupations.

But once begun, his acting career progressed surely, steadily. Today he is one of Hollywood's substantial leading men, with none of the discomfort of sudden and sensational Fame.

He lives quietly, and only on occasion does his exuberance manifest itself in a super automobile, or some other extravagance. He is married to his school-day sweetheart. They have two small daughters. With singularly few exceptions, Bob's life is in nowise different than if he were the crack salesman for some large business concern.

The three close comrades on the screen are casual comrades in their interests and their work. But the vital differences not only in their beginnings and their backgrounds—but in their personalities and their present lives—make a good, if not an intimate friend of the other two.

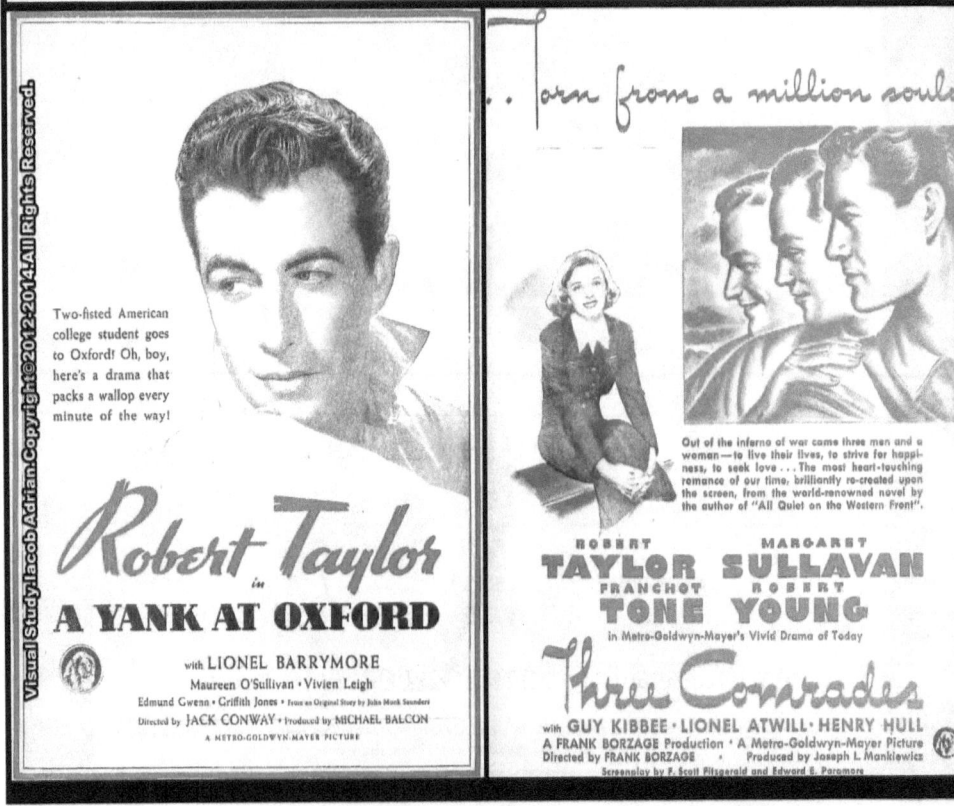

Who Bosses Bob

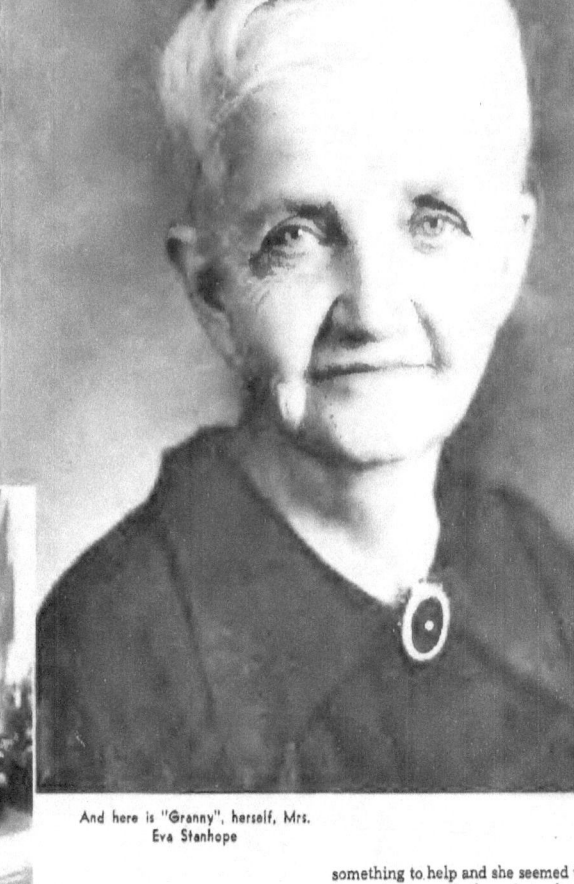

And here is "Granny", herself, Mrs. Eva Stanhope

"Granny's" house always meant good eats, good fun, good stories, and an understanding shoulder on which to lean when boydom difficulties arose. She was a solace in any storm and she is still one today. He still runs to her with his problems, he still drops in with his "girl friend" seeking approval —and he gets it too, since one Barbara Stanwyck rates almost as high around that house as he does—and he still brings her little presents, just as he used to bring her fish he had caught, field flowers he had picked in the old days. Between these two, there is a delightful companionship and a Mutual Admiration Society which throws an entirely new light on this particular dark-and-handsome of the screen.

■ We know him as "Bob Taylor," but Mrs. Stanhope shudders when she hears that name, and still insists on calling him by his real name, "Arlington." This very definite preference of hers gave rise to a rather delicate situation several years ago when Mrs. Stanhope and her daughter, Bob's mother, first settled down in Hollywood. It was after Bob had made *The Magnificent Obsession* and the fan mail began pouring in at such a rate that it was more than Bob and his secretary could handle alone. As Bob tells the story: "Grandmother insisted that she should be allowed to help answer the mail. She suggested I go over the mail once each week, tell her the general drift of what I wanted to say in each letter, and then she would do the actual dictating. She was so anxious to do something to help and she seemed to think it would be such fun, that of course I agreed.

"Well, I guess Grandmother did have fun in her way, but it was kind of hard on the secretary. Grandmother just couldn't help letting her personal opinions creep in The letters would start out all right, but along about the second paragraph she would always forget that the letter was from me, and she would begin telling some of her own personal recollections: what I used to do as a little boy; what a good little boy I had always been; how I used to take

Irene Hervey used to be the girl Taylor took to Granny's, (a nice compliment to any young lady, we'd say) but that was some years ago, before she married Allan Jones

Meet The Woman Who Bosses Bob

her to baseball games, and football games and church; and how she always had ginger cookies for me in a jar whenever I came to see her. Things like that, until the secretary would call her off that track and put her on the right one.

"We got her straightened out on that after a while, but we never could cure her of sticking one idea into those letters. It was almost like a form paragraph and it always crept in. It read like this: 'No, Bob Taylor is not my real name. It is Spangler Arlington Brugh, and I was born in Nebraska. As a matter of fact, my grandmother does not like the name of Bob Taylor at all, and cannot understand why they ever wanted me to change it, since the name Arlington is so much more beautiful, and that is what I have always been called. It's a family name, handed down from generations, and Bob is so ordinary by comparison.' I remember once I caught her right in the act of dictating that. She was sitting there with a big knitting bag by her side—filled with letters, not knitting; she carried it everywhere!—and she looked so cute and guilty I had to laugh."

Then a few months later, when the mail began arriving in such piles that Grandmother was all but buried alive under it, Bob knew that it was time he got her out from under it entirely. But he knew better than to come out with it bluntly. He tried tact, with a little quilting information thrown in—and here's the way it worked, at the dinner table, one Sunday noon, when Bob had stopped in for lunch with the family:

Bob: (after having downed a mouthful of mashed potatoes) "Say, 'Granny', how much did you get for those quilts you used to make at the church back home?"

"Oh, I don't know, Arlington . . . it depended on the size. Sometimes fifteen dollars, sometimes twenty. I know we used to figure we could keep a whole family for a month on the proceeds. It was all for charity. Why?"

"Because somebody was telling me they raffled off a quilt at a church bazaar, on Highland somewhere, and one quilt brought sixty-five dollars!"

"Sixty-five dollars! Why, what our club could have done with that!"

"This club has plenty to do with it, too. They're getting ready for their Thanksgiving baskets."

For a moment Grandmother still mused over the amazing information her grandson had just divulged. "I can't believe it—church socials in Hollywood . . . quilting bees! Funny, I just didn't think they'd exist out here."

"Oh, they exist all right. Jeanette MacDonald's mother goes to some quilting club that meets every Tuesday and Thursday."

Out of the corner of his eye Bob could see that his grandmother's interest had been trapped. From that day on Grandmother relieved herself of the mail work for the enterprise of quilting for charity.

"Granny" has many fine stories to tell about Bob. When he was eleven or so, he had his first pony, a temperamental young rascal named Gyp. Gyp was a birthday present, and immediately Bob wanted to ride her over to Grandmother's to show her off. That was a distance of fourteen miles, and before leaving he phoned her that he was coming. Grandmother also interpreted that call as a warning to have something good to eat ready and waiting when he arrived. She waited quite a while and then came another call. It was Bob again. "I'm sorry, Grandmother, but I'm not even half way yet. Gyp keeps turning around and wanting to go home and we only go three yards ahead and then two back, and I don't think I'll ever get there. What'll I do?"

"That's up to you," Grandmother said sternly, though there was a smile in her voice that she was trying to hide. "But you'd better make up your mind right now, young man, who's to be master—you or the horse?" And she hung up.

Three hours later he arrived. It had been no small battle, but he had won. Now

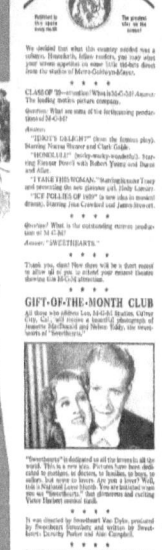

when Grandmother tells that story she points out the moral proudly. "Of just such little things as that a man's character is built."

Then there was that other time when he walked to Grandmother's, the whole fourteen miles through a raging summer storm, arriving rain-soaked and mud-splattered from head to foot. He had started out on his bicycle with a boy pal, but when they ran into the storm they had had to park their bicycles in somebody's barn, and continue on foot. When they got there Grandmother made them undress and put on some of her husband's clothes until she could dry their own. Then she said, "Now, Arlington, I see that you've got a secret to tell. Nothing else could have brought you all this way in the rain. Now hurry, out with it, before you burst."

She had hit the nail on the head and the story came out in leaps and spurts. The night before Arlington and Gerhart had had the most amazing adventure! They had been bicycling over to see Mary Ellen (the best girl in his life at that moment), and peddling along a lonely road they passed a car stalled along the side. A man called out to them and asked them where he could get a lantern. There was something wrong with his engine, and he knew how to fix it, but it was too dark to see. Then he gave them some information which made their eyes pop. He was a convict, he admitted, from the State Prison Farm. He had been granted a 24-hour parole, and he had already used twenty-two hours of it. Now he had to get back or else! To the boys it was as exciting as though they had suddenly been held up at the point of a gun. They lost no time in scurrying off to the nearest farmhouse, and a few minutes later they were back with a light.

"You mean you were frightened of the man?" Grandmother asked, as Arlington paused for a moment in the telling. "Why, what could he have done to you? You could have just gone off and never come back!"

"Aw, Grandmother," he said disappointedly. "You don't understand. You think we got the light for him because we were *afraid*? Heck, no! We just wanted to get a good look at him ourselves! A *convict*, Granny! The first one we ever saw in our lives."

Today it's quite a different young man who comes to Grandmother's house, and the mode of his arrival is quite a little different, too. It's a black Packard which rolls up now, and it's no longer Gerhart who accompanies him up the walk, but a young lady. He no longer sits in front of the fireplace in his grandfather's too-big clothes, with remnants of mud still on his cheek. He sits there in expensive sport clothes, and now there are other things to discuss besides convicts along the road. But essentially he is the same; essentially the relationship between grandson and grandmother is the same. She still finds fault with him and she still

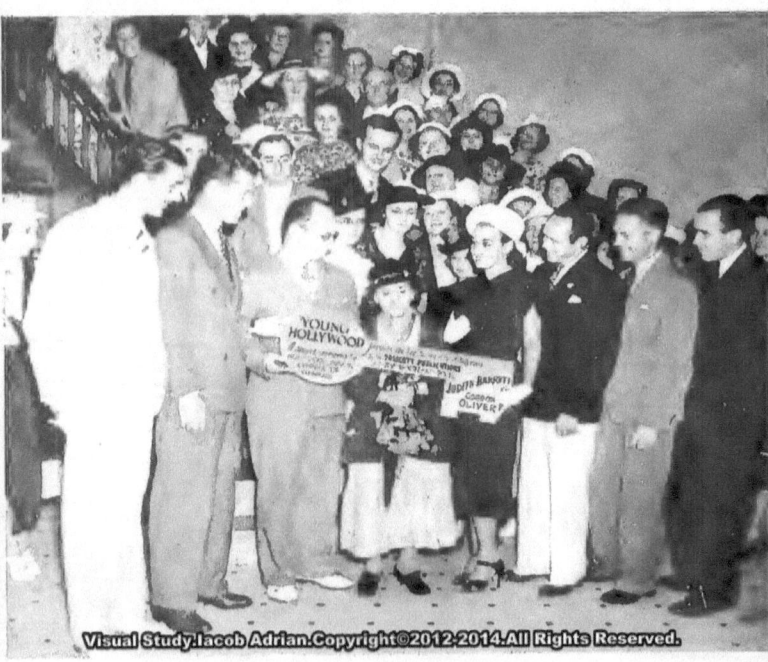

Representing the Hollywood Junior Chamber of Commerce, Gordon Oliver and Judith Barrett turned up at the station to welcome the Movieland Tourists, and presented the key of the city to the senior member, the charming little sight-seer who has celebrated her eighty-third birthday

finds much to praise. She has not let her new success in the world affect her opinions, not one whit.

One of the things that most upsets her about Bob Taylor of today is that rugged, sun-tan color he has acquired during the last few years. Invariably as he steps in the door, she says, "Oh, Arlington, I had hoped that you would give up this tanning business. Your nose is peeling and you look like a young Indian! Please!" And then Bob explains all over again for the forty-eleventh time that a fellow can't have a ranch and ride horses and raise alfalfa and play tennis in the California sun *without* getting burned and peeling now and then. And besides he likes it that way. So in the end the discussion never arrives anywhere; Grandmother still sticks to her ideas, and Bob still peels.

Another opinion that Grandmother has is that Bob should get more fun out of life. She is inclined to believe that he lets fame rob him of too much. "Now for example," she said, "Arlington gave me a beautiful white fur jacket last Christmas to wear with my formals—" Oh yes, Grandmother is very modern in the clothes-respect— "and then he invited me out for an evening, so I could wear it, I guess. Barbara went along too, and we all went dancing some place. To one of those night clubs. But everybody stared and looked at us so that it got uncomfortable after a while and we decided to move on somewhere else. We went to the Palomar next, and we were just beginning to have a wonderful time there when the same thing started all over again. People asking him for autographs; strangers dancing right up to him on the floor, saying, 'Hi there, Bob Taylor'—dreadful name!—and everybody watching and listening to everything he said. So we had to leave there, too. Things like that happened so often that after a while Arlington just didn't want to go out any more at all. But finally I had a good talk with him about it, and scolded him a little. Barbara and I together did. Because Arlington is a boy who likes gaiety and dancing, and if he's going to stop those things, just because of being stared at, then he'll grow old in no time. I tell him he just *can't* be so sensitive. A man in this business just can't be sensitive about what people say or do or write about him—or he won't have any youth. And youth is the most important thing in the world.

"Then after youth, the most important thing in the world is a happy home life. I tell him, and Arlington knows it too, that all the money and all the fame in the world doesn't mean anything, if you're not happy in your home. So pretty soon, I guess, Arlington will settle down to that, too.

"Of course he's got a cute little home now, but it's a bachelor's home, and no bachelor's home is complete. But he does have a few little things around to remind him of his old home and of us, his mother and me, and to make him look forward to another, more real, home when he's married someday. He's got a silver napkin ring I gave him twenty years ago, with his name on it, and he uses it even now. And he's got the same old cookie jar I used to keep full of ginger cookies, and every now and then I send him over a batch so he can keep it full now. Things like that keep a man remembering what a home life can really be like even if he is a movie star."

Grandmother suddenly looked at the clock and jumped. "Oh, I'm sorry, but you'll have to excuse me now. Arlington and Barbara are coming for supper and I want to get everything ready for them. There are a couple of little things I bought for them today—sort of as a little joke. Would you like to look at them? See, it's the maid's night out and Barbara and Arlington are going to get the dinner themselves."

There on the dining room table reposed an apron for Barbara, of blue, yellow and red printed calico, and beside it was a white chef's cap for Bob.

"What am *I* going to do?" Granny laughed, and a twinkle came into her eyes. "Why, while they work I'm just going to sit around and tell them what to do!"

So in a way it's still much as it used to be, Grandmother still rules the roost. The roost has moved from Nebraska to Hollywood, and the trimmings are a little different, but Bob still likes to go there just the same!

They Built a New America with Glory and Guns... They Were MEN That Women Could Love!

The grandest adventure-romance since "Cimarron" stormed the screen... crowded with stars, action and thrills!

WALLACE BEERY
ROBERT TAYLOR

STAND UP AND FIGHT

FLORENCE RICE · HELEN BRODERICK · CHARLES BICKFORD

Screen Play by James M. Cain, Jane Murfin and Harvey Ferguson · A Metro-Goldwyn-Mayer Picture
Directed by W. S. VAN DYKE II · Produced by MERVYN LEROY

THE LION'S ROAR

Published in this space every month

The greatest star on the screen!

We decided that what this country needed was a column. Henceforth, fellow readers, you may whet your screen appetites on some little tid-bits direct from the studios of Metro-Goldwyn-Mayer.

★ ★ ★ ★

CLASS OF '39—attention! What is M-G-M? *Answer:* The leading motion picture company.

Question: What are some of the forthcoming productions of M-G-M?

Answer:

"IDIOT'S DELIGHT" (from the famous play). Starring Norma Shearer and Clark Gable.

"HONOLULU" (wicky-wacky-wonderful). Starring Eleanor Powell with Robert Young and Burns and Allen.

"I TAKE THIS WOMAN." Starring Spencer Tracy and presenting the new glamour girl, Hedy Lamarr.

"ICE FOLLIES OF 1939" (a new idea in musical drama). Starring Joan Crawford and James Stewart.

★ ★ ★ ★

Question: What is the outstanding current production of M-G-M?

Answer: "SWEETHEARTS."

★ ★ ★ ★

Thank you, class! Now there will be a short recess to allow all of you to attend your nearest theatre showing this M-G-M attraction.

★ ★ ★ ★

GIFT-OF-THE-MONTH CLUB

All those who address Leo, M-G-M Studios, Culver City, Cal., will receive a beautiful photograph of Jeanette MacDonald and Nelson Eddy, the sweethearts of "Sweethearts."

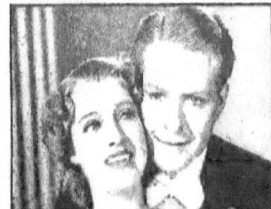

"Sweethearts" is dedicated to all the lovers in all the world. This is a new idea. Pictures have been dedicated to mothers, to doctors, to families, to boys, to sailors, but never to lovers. Are you a lover? Well, this is National Lover Month. You are initiated when you see "Sweethearts," that glamorous and exciting Victor Herbert musical thrill.

★ ★ ★ ★

It was directed by Sweetheart Van Dyke, produced by Sweetheart Stromberg and written by Sweethearts Dorothy Parker and Alan Campbell.

★ ★ ★ ★

In addition to Sweethearts MacDonald and Eddy, the cast includes Sweetheart Frank Morgan, Sweetheart Ray Bolger, Sweetheart Florence Rice, and that trio of sensational Sweethearts—Herman Bing, Mischa Auer, Reginald Gardiner.

★ ★ ★ ★

This truly big picture has been filmed entirely in technicolor.

★ ★ ★ ★

Love is sweeping the country.

—*Leo*

Report On Cuba

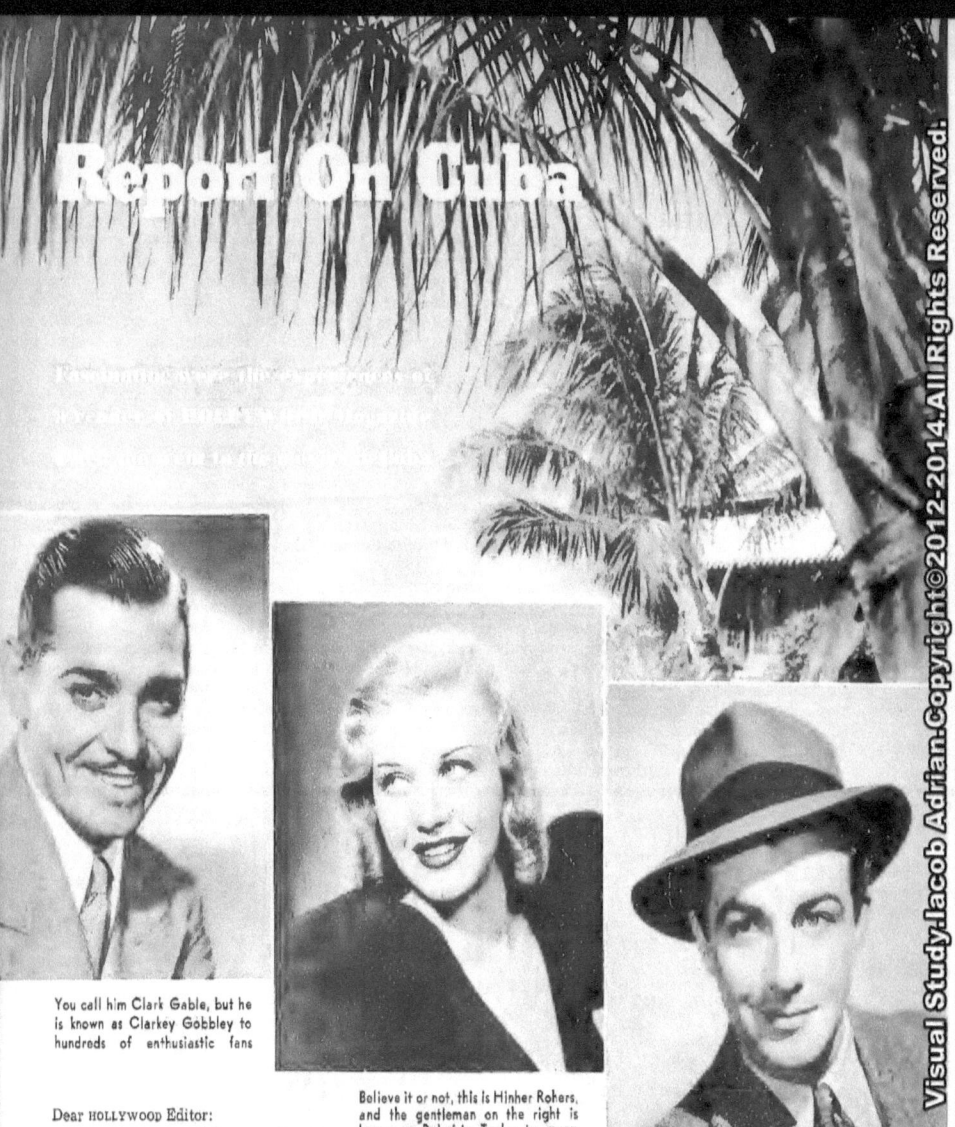

You call him Clark Gable, but he is known as Clarkey Gobbley to hundreds of enthusiastic fans

Believe it or not, this is Hinher Rohers, and the gentleman on the right is known as Robairto Teelor to many adoring maidens in the South

Dear HOLLYWOOD Editor:

I have just returned from my first trip to Cuba—not the Cuba of Havana with its smart shops and hotels and sophisticated inhabitants. But the small towns of eastern Cuba, where life is less cosmopolitan and the inhabitants, just as charming, are simpler. It was there I learned something I thought might be of interest to you and to other readers of HOLLYWOOD the fact that Cubans love American movies.

I love movies myself. Most of my friends are ardent fans. But our interest pales into positive indifference compared with the passion of our Cuban friends. I have never seen anything like it. When a Cuban hates he hates, and when he loves he loves. And there is no doubt that they love movies with all the fire, the violence, and the single-heartedness of the Latin temperament.

I learned this the first day. I was sitting in the lobby of a small hotel, waiting for my father. A movie magazine was open on my lap but I wasn't reading. I was looking instead out on the dusty, sunny street, with its palm trees and great colorful flowers and its low-voiced, slowly-moving passersby. It was a different world from any I had ever known.

Suddenly a girl sat down on the couch beside me. She was about seventeen, shy, and very lovely with her olive skin and dark eyes. She pointed to the magazine in my lap.

"You like Clarkey Gobbley, si?" she asked eagerly.

"I beg your pardon?"

"Clarkey Gobbley. You like him, si?"

I was baffled. Then shyly, but still eagerly, she pointed to the picture on the page in my lap. Of course! Although many of the younger Cubans speak and read English, they still pronounce our proper names in Spanish. Who else could Clarkey Gobbley be but—Clark Gable!

"Oh, yes!" I said. "I mean—si! Do you?"

What a torrent of praise I had called forth! She chattered in Spanish and in English, she rolled her eyes ecstatically And she threw questions at me faster than I could answer. Was not Clarkey muy bueno? And what of Robairto Teelor? She paused expectantly—and for breath.

Yes, I liked Robert Taylor. And Hoan Crawford? And so-beautiful Hinher Rohers?

The last one had me stumped until I had time to translate. Ginger Rogers, of course. Oh, yes, I was particularly fond of Ginger. On and on the senorita chattered, asking hundreds of questions, most of which I could not answer. We talked movies until my father came. And after that, we were fast friends the whole time I stayed at the hotel, and all we ever talked about—or rather, all I was ever talked to about—was movies.

It dawned on me after I had talked with her, and with other young Cubans, that to them movies are not acting but real. This was illustrated in an amusing way once when my father and I were talking to a group of Cubans.

The name of Charlie Po came up. When we looked a little blank, they were obviously disgusted with our ignorance. Why, they said, he is the greatest detective the world has ever known. He is a Chino (Chinaman) but he travels all over the globe and no one who has ever lived can do the miraculous things he has done. Beside him our English detective, Sherlock Holmes, is a bobo (fool). I then had a brainstorm and said, "Oh, you must mean Charlie Chan."

Si, si, only they call him Charlie Po. Why this is I never discovered, but they were loud in their praise and declared that if ever Cuba had a murder mystery they hoped the Cuban government would send for Charlie Po at once to solve it.

Movies are so real to them that whenever a Clarkey Gobbley or Robairto Teelor picture is shown, the senoritas dress in their finest and fall all over themselves to get front row seats. Much as our mothers, I suppose, sat on the front row of the legitimate theatre in hopes that the matinee idol of their day might notice them.

They love Chiquita Shearley Templey, too. To them she is *la mas simpática que todas* (the most winsome little girl of all). *Platinos* (blondes) are more popular than brunettes, and Mae West is a great favorite. *Mequilito Musey* (Mickey Mouse) is the most popular comic strip, and at westerns and gangster pictures they get so excited that the noise they make can, literally, be heard for blocks.

Once when I was in one of the smaller towns I noticed a sign in front of the movie theatre that announced in big letters, "Ginger Rogers in person, SOON!" I got quite excited because I had known Ginger as a little girl in Fort Worth and I wanted to see her again.

So I went to the manager to find out when she was to arrive. He told me with eloquent, sad gestures that unfortunately the beautiful *platino* was kept in the States this time, but that she would certainly arrive at a later date. After that, from time to time whenever one of Ginger's pictures was to be shown, the sign would appear again. Of course she never arrived. But the manager always had a valid excuse and I discovered that, neither in his own mind nor in the minds of his ardent customers, was he doing anything dishonest. Seeing Ginger on the screen was just like seeing her in person, to them, and they were just as enthusiastic as if she had appeared in flesh and blood.

One of the last evenings I was on the island I went to a G-man picture with my father. It was Saturday night, and the house was packed. The townspeople all came, as well as the farmers and workmen from surrounding plantations in town for the day, with their wives and children. It was a colorful audience. You saw, occasionally, a woman in a *mantilla*, now seldom worn, or a young girl with flowers in her hair. Some of the men from the country wore *machetes* (a short, sharp sword-like knife). The flow of their soft voices was like music, with here and there a staccato note. The place was alive with voices before the picture started, but even when the lights dimmed and the title was thrown on the screen they didn't stop talking. They simply changed the subject of conversation. They began talking to the characters in the picture, or about them. It was shown, as nearly all American pictures are, with English sound and Spanish sub-titles.

The G-men they greeted with enthusiastic shouts and cheers. The villainous gangsters they greeted with cries of *"Quite se!"* Which is the Spanish equivalent of "Take it away!" When one of the G-men was killed, the man next to

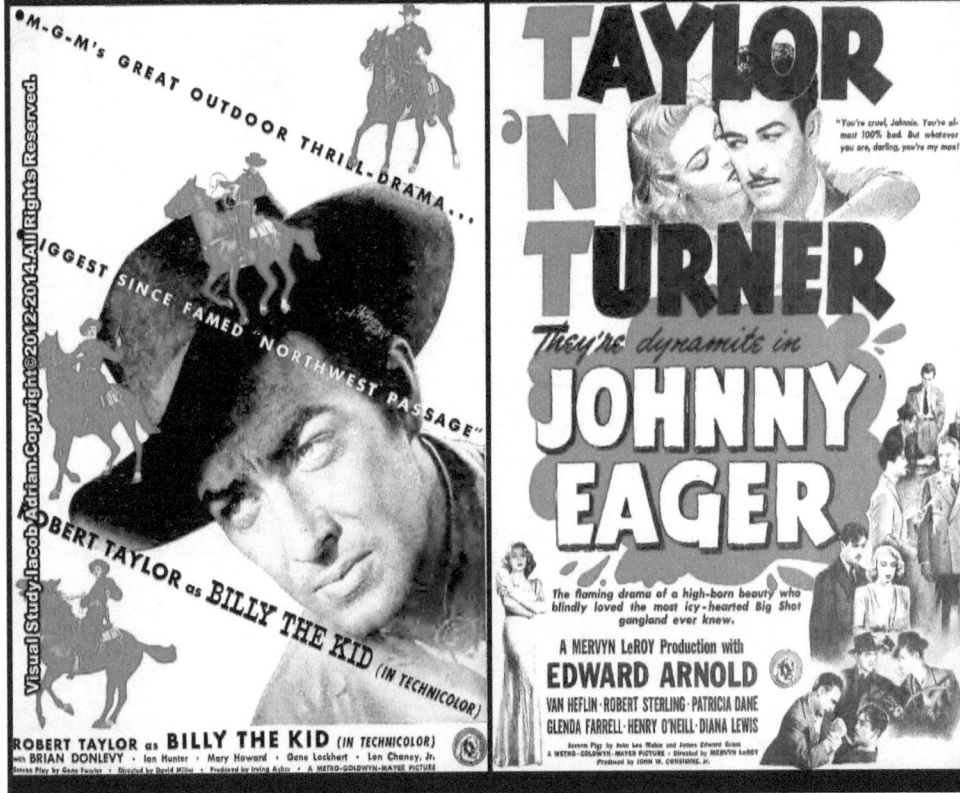

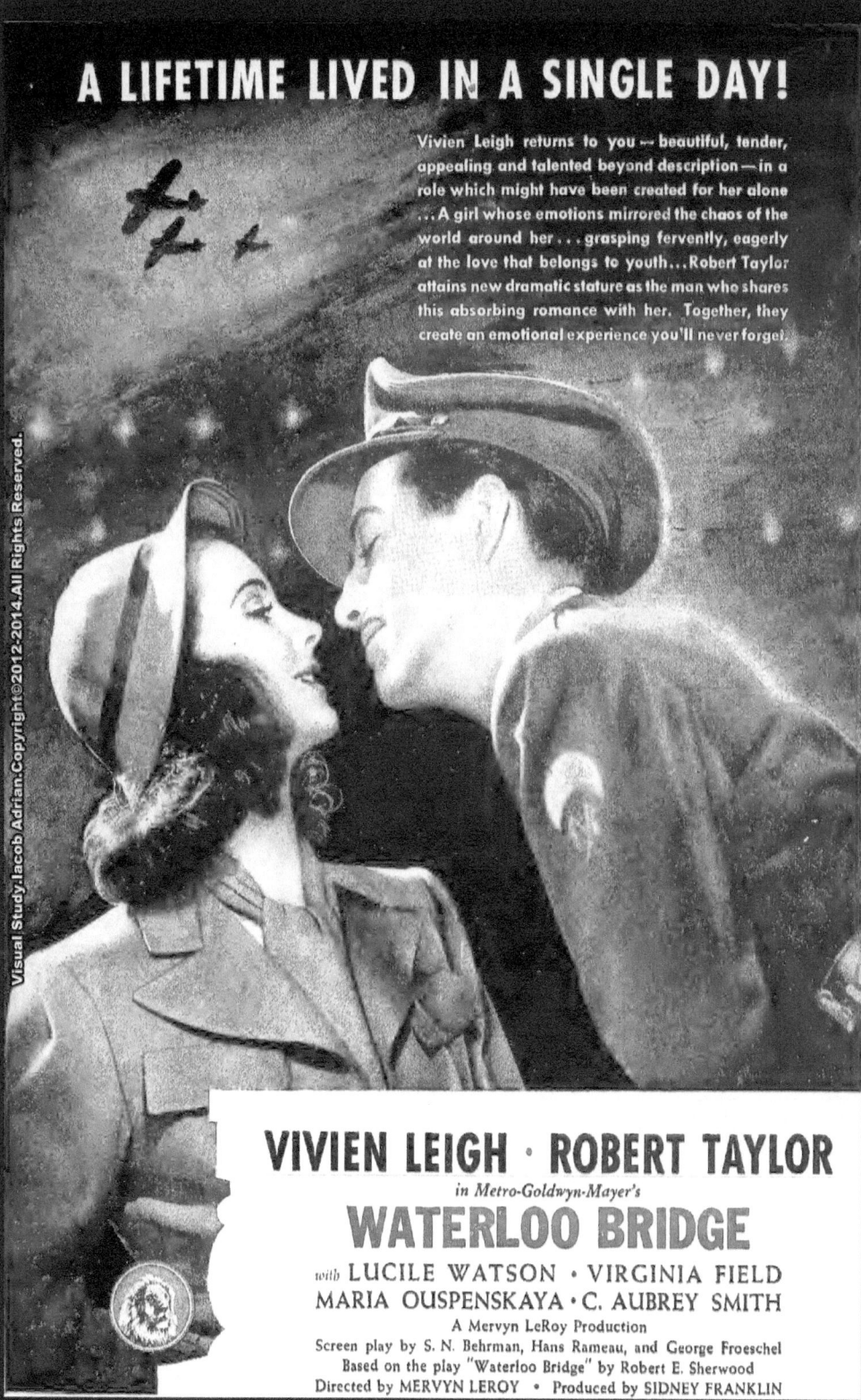

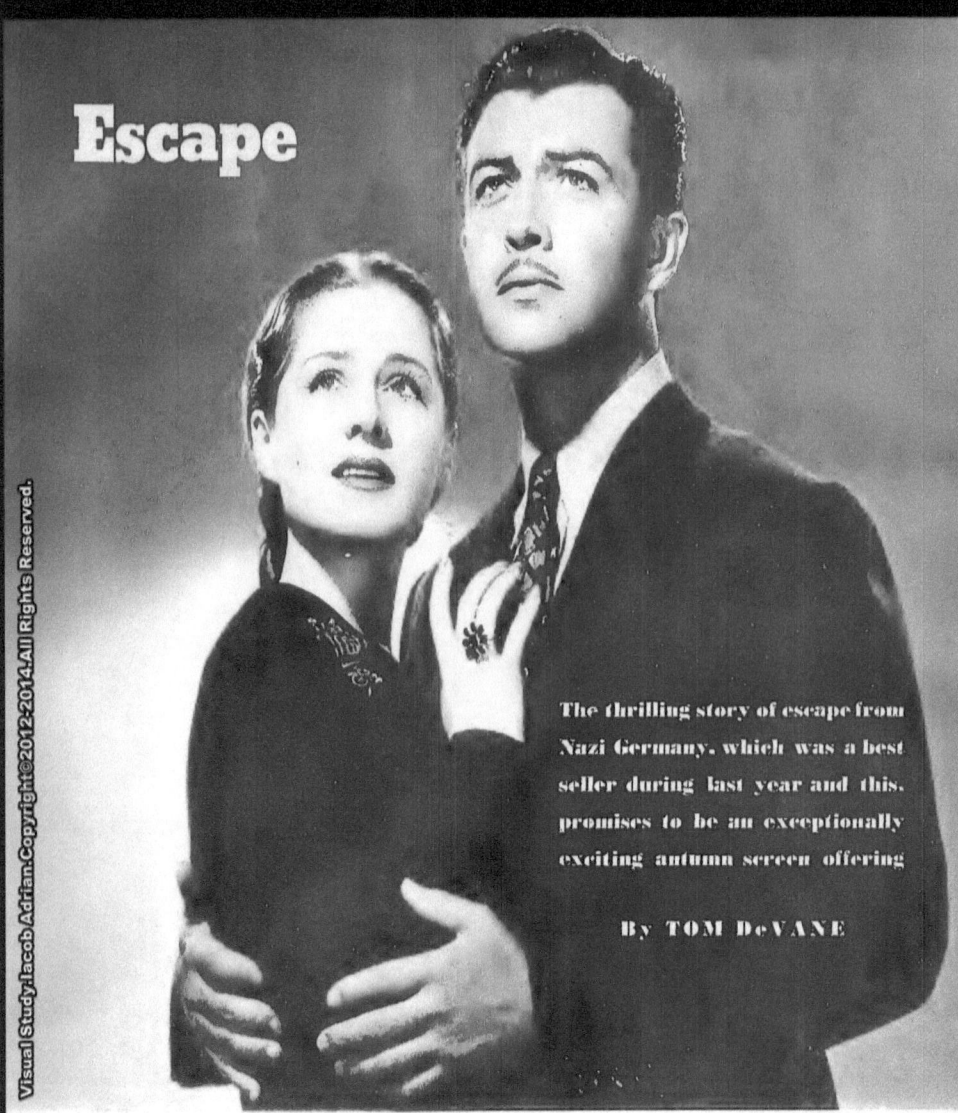

Escape

The thrilling story of escape from Nazi Germany, which was a best seller during last year and this, promises to be an exceptionally exciting autumn screen offering

By TOM DeVANE

Robert Taylor as the desperate man who tricks the Nazis into releasing his mother from prison camp. Norma Shearer as the courageous Countess who risks her life to help

■ The *Countess von Trenck* stepped out of her portable dressing room, the largest and flossiest these eyes have ever seen in a good many years of movie-set wandering. For one fleeting moment she held her regal pose—then she wriggled her nose, twinkled her eyes, and became Hollywood's own Norma Shearer.

It was between scenes on M-G-M's *Escape*, and obviously there was something in the air. Nearly all the set workers had stopped their labors, waiting for a signal from Miss Shearer, who was carrying an elaborately-wrapped package. She asked someone, "Where is he?" and was assured that "he" was in a corner of the set. "All right," beamed Norma, "let's start it!"

The sound man started the huge "playback" machine. Immediately the stage was filled with the enthusiastic strains of "Happy Birthday to You." Miss Shearer, bearing her package, took the arm of Mervyn LeRoy, producer-director of *Escape*. Others followed. Soon there was a long procession daisy-chaining its way to the corner of the stage, where an embarrassed Bill Cotton (Le Roy's assistant) was wishing that such things as birthdays had never been thought of.

Norma said simply, "Happy birthday from all the gang, Bill!" embraced him warmly and handed him the package. The record (especially recorded by the whole troupe one day when Cotton was off the set) continued blaring forth its loving message, while everyone applauded.

That's Norma for you. In the midst of making one of the most important pictures of her career, in a role that would have most "serious" actresses who "live" their roles immersed in gloom (*Escape* is not the cheeriest story in the world) the star still finds time to have fun. What's more, she sets great store in birthdays.

Miss Shearer would have graced any party the day we visited M-G-M and *Escape*. To our masculine eyes, her heavy white wool cape, with gold scroll embroidery around

Escape

its military collar—was stunning enough. But the lassie with us whispered excitedly, "See! It's a new trend! *Adrian is bringing back the cape!*" We were in the midst of an authentic style scoop, and didn't know it. The illustration on this page will give you an idea of what we mean. And how do you like Norma's new hair-do? She parts it in the center and wears it with two loose knots in the back. Bee-youtiful, we say.

Escape, as you probably know, is the famous Ethel Vance best seller in which M-G-M is presenting Miss Shearer with Robert Taylor as co-star and a distinguished cast headed by Nazimova, Conrad Veidt, Felix Bressart, Bonita Granville and Blanche Yurka. Mervyn LeRoy, that perennial boy-wonder of the cinema, is in charge of the works.

Although Miss Vance's novel naturally bears angry anti-Nazi sentiments, the studio is concentrating on the romantic and thrilling aspects of the plot. The romance between the Countess and young Mark Prcysing (Robert Taylor) will be given more prominence in the screen version.

The main plot of *Escape*, however—the melodramatic and spine-tingling efforts of Emmy Ritter's son, Mark, and his friends to rescue the great actress from a concentration camp, remains just as thrilling as it was in the book.

Emmy Ritter, you see, was known as a great American actress, in spite of her German birth. Of recent years her home in New York had become a haven for refugees, all of whom she welcomed with open arms. She made the fatal mistake of returning to Germany to dispose of her property—eventually managing to smuggle the money out of the country. The Nazis no like—not for one minute. Emmy is thrown in the pokey and sentenced to hasty execution.

Before they have a chance to chop her head off, however, she gets appendicitis and has to have an operation. It is while she is lying between life and death, befriended only by the young doctor who performed the operation, that her son, Mark, arrives, searching for her. When his efforts to battle official Nazidom finally fail, he enlists the terrified aid of the American-born Countess, whom he had met romantically in New York.

In the role of Emmy Ritter, the great Alla Nazimova is making her "talkie" debut. The "talkie" should tip you off—Nazimova is known to movie fans of an earlier generation. She quit before the silver screen had a chance to talk back. Not that it mattered—the lady has starred with great success in Ibsen dramas all across the country for the past decade.

Nazimova giggles when she tells of her first day's work in pictures after all these years. "I knew what was going to happen," she told us, "but it was still a shock. They take me and put me in a coffin and nail the lid down!"

It was a very nice coffin, however—all done up for Nazimova—with extra heavy shoulder pads. And—of all things—a head rest, rather like the ones you see on barber chairs. Madame Nazimova didn't mind. "After all, Robert Taylor had to carry me to the coffin," she smiled. "Think how many women would want the same experience!"

The interviewer interrupted to tell Nazimova that the great Sarah Bernhardt used a coffin as a bed for many years. Mme. Nazimova's fragile body shook with laughter. "I went to sleep in mine, too, one night at the studio. But I do not like coffins for all the time."

The M-G-M grapevine insists that Nazimova will give a spectacular performance in *Escape*.

■ "I am a lucky woman," she says, seriously, "to return to the screen in such a good part. I've had other offers, of course. This studio wanted me to play Madame de Farge in *A Tale of Two Cities*. I was interested until they tell me that I am to have a knock-down fight with Miss Edna May Oliver. I mentally compare my size with that of Miss Oliver and I say, 'Oh! No!'" (Nazimova is slightly over five feet tall and a bit over one hundred pounds.)

"So I say to them, you should get a tall woman for that part. Why not try Blanche Yurka, that great woman, who would be wonderful? And they did, and she *was*.

"Yurka plays my prison nurse in *Escape*, you know. And she is so wonderful, that one. As long as I'm helpless in bed, I won't have to wrestle with her!"

Also in this same prison sequence is a young actor that the studio thinks will prove to be a hit. Just because we didn't know an Adrian style scoop when we face it, we'll tip you off to this one.

Philip Dorn is his name. In his native Holland, a few short years ago, he was known as the Clark Gable of the Netherlands. He played all of the typical Gable movie roles on the stage. You know—*Men in White* and *Idiot's Delight*. He was brought to this country some time ago by Joe Pasternak, the Universal producer who discovered Deanna Durbin and Gloria Jean. He was told to sit back in some cool dark spot and improve his English (it wasn't very bad when he arrived). So sit he did—and inside of six months his English was flawless. His screen debut was in *Ski Patrol*, and although the picture did not set box office fires, he made a personal hit.

■ Negotiations to borrow him from Universal proving unsuccessful M-G-M promptly pulled strings and bought his contract. And they have important plans for him. Dorn's no Arrow collar ad, but he has a lot of masculine oomph. Bet you'll like him.

In the role of the sinister *General* is the distinguished continental actor, Conrad Veidt. A star these many years (he was in the famous *Cabinet of Dr. Caligari*), Veidt is a stunning figure in his uniforms.

Robert Taylor still has the moustache so many girls think attractive. His *Escape* role should do a great deal to further his growing reputation as an actor of real ability. Personally, we're glad that his studio has given up its strenuous campaign to put him over as a junior edition of Wally Beery in the he-man roles. He's much more suited to sensitive, dramatic roles such as the one he had in *Waterloo Bridge* and in *Escape*.

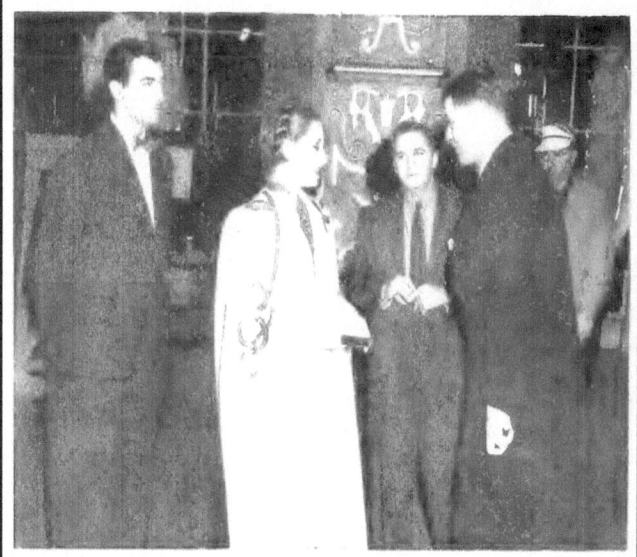

Norma Shearer, in the dramatic cape which is expected to set a new vogue, meets Philip Dorn who plays an important role in *Escape*. In the background, Robert Taylor and producer-director Mervyn LeRoy look with admiration at her hair-do

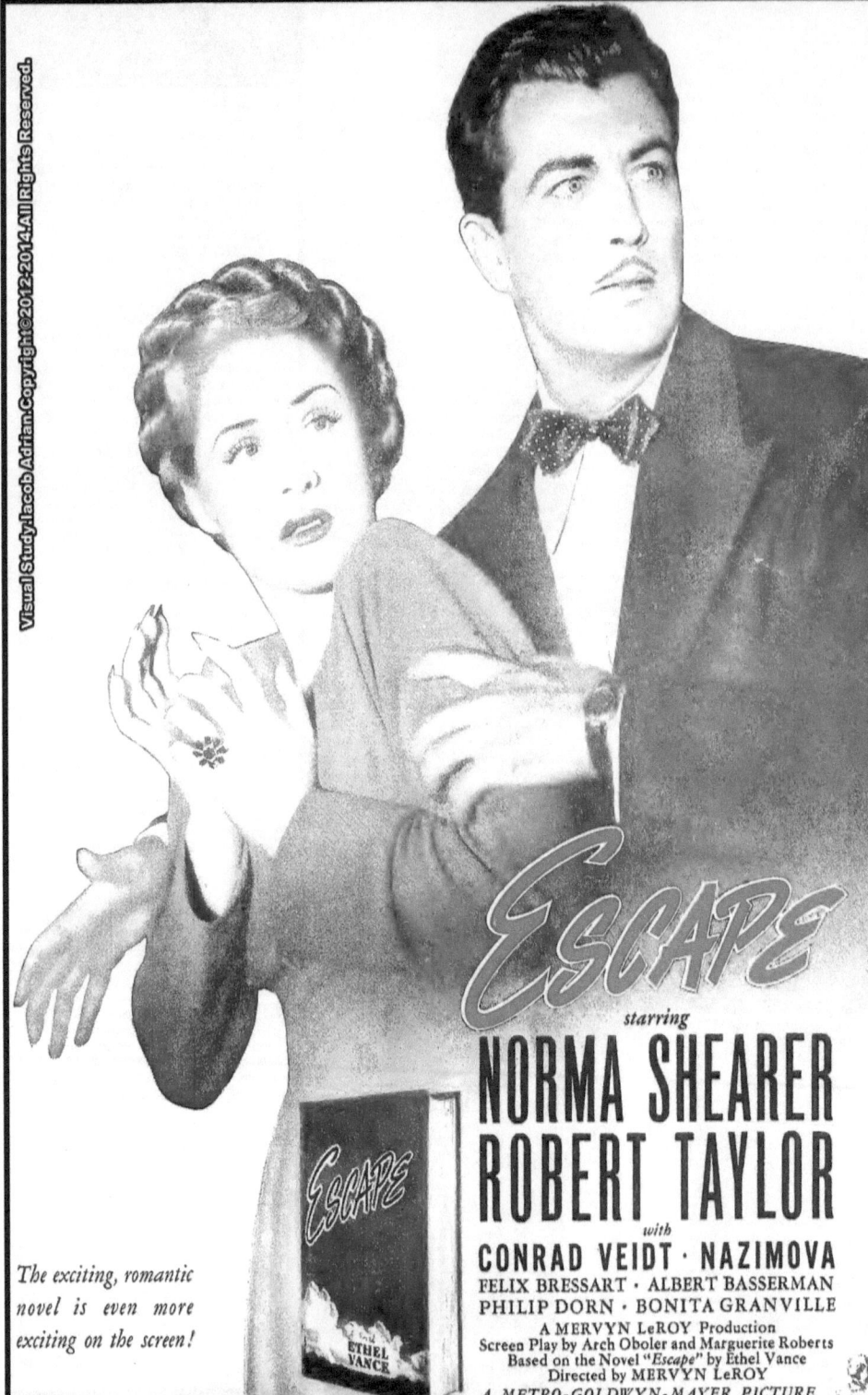

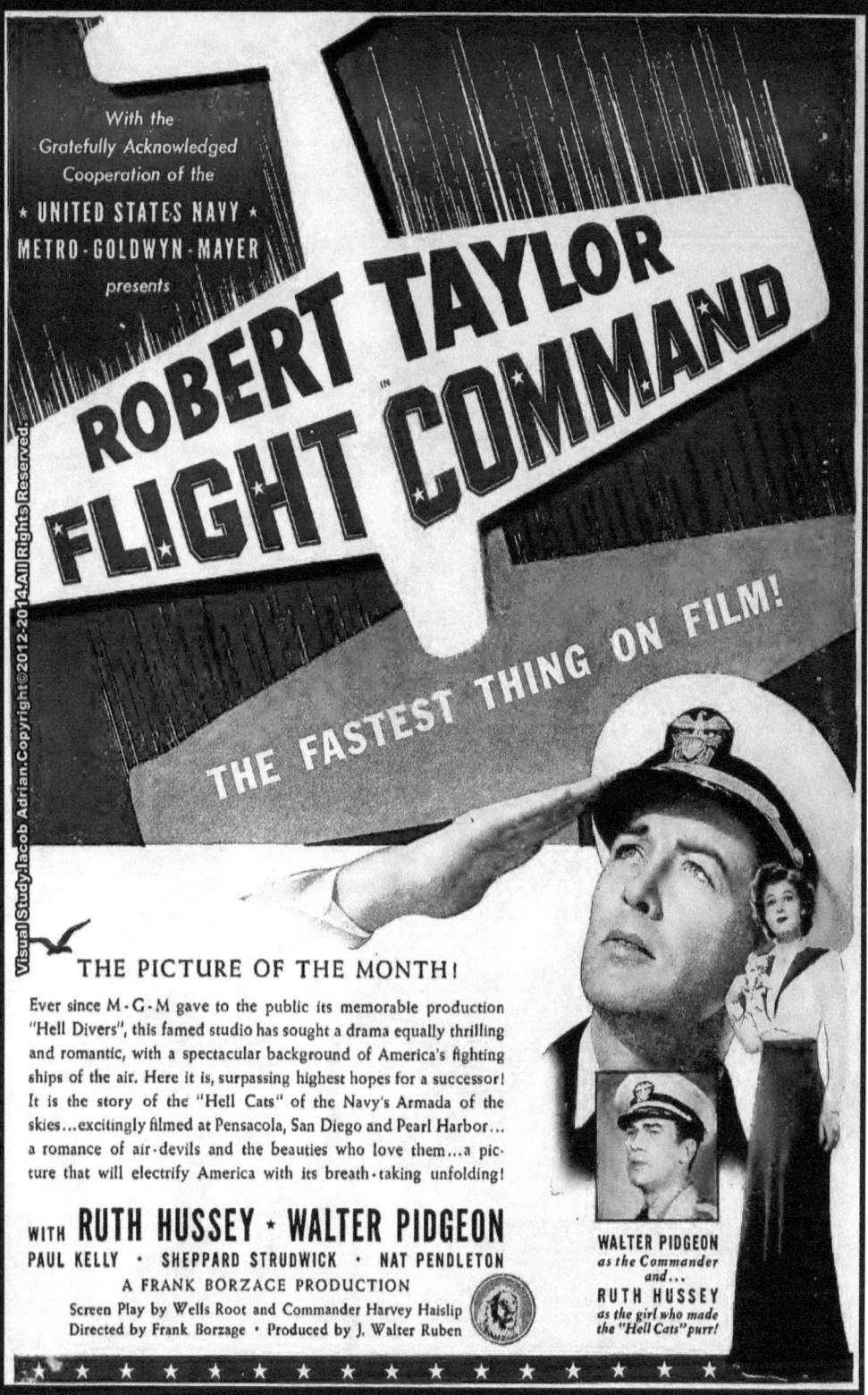

Bob Taylor portrays tough gunman in his new Metro film, *Billy the Kid*

Meet
Two-Gun Taylor

Bob Taylor plays his first western role in M-G-M's *Billy the Kid*. Bob's role in this film, that of a young outlaw and desperado, is the fulfillment of a four-year ambition

By DUNCAN UNDERHILL

■ Better watch your language, pardner. What's that you called Robert Taylor? Matinee idol? Collar model? Them's fightin' words, waddy, if you're referring to the terror of the Badlands, the scourge of the redskins and the meanest varmint that ever drew first on a deppity.

Two-Gun Taylor's in a dangerous mood. He's out to make good on a bet that may switch his career, a bet that he's been hankering for nigh onto four years. It was 1937 when he began heckling his studio to let him play *Billy the Kid*.

The objections were strenuous and seemingly valid. Robert Taylor bears no physical resemblance to the famed gunslinger. He's noticeably older than Billy, who died at twenty-one with twenty-one notches on his gun, not counting Indians and Mexicans. He's not, in short and ugly words, the type. Nor have the great-lover roles in his seven-year career fitted him to portray the frontier bully he regards as the vividest character in Western history.

Yet Two-Gun Taylor stuck to his guns and kept firing away at the front-office big shots with salvos of arguments, briefs and plain appeals until they finally surrendered to save wear and tear on their nervous systems.

When the studio moguls gave in they raised a white flag the size of a bed sheet, capitulating not only on the single point of letting the star have his pet story but also handing him an oversize budget, Technicolor, Maureen O'Sullivan, Brian Donlevy, Ian Hunter and Director Frank Borzage. So now it's up to Taylor to come through or spend the rest of his career wondering how to get back off that lonely limb he's out on.

The street-corner wiseacres who make their office on the curb at Hollywood Boulevard and Vine Street professed real astonishment when they learned that Bob was going to try to get inside the character of a gun-toting desperado.

"Who will it be?" they inquired of each other. "Baby-Face Nelson or Pretty Boy Floyd?"

An additional touch of bravado is lent to Bob's dare-devil undertaking by the fact that he will be in direct competition with another Billy the Kid who seems to be closer not only in years but in background and appearance to the blood-stained bad boy of the Indian country. What makes it tougher still is that the rival Billy is backed by the fabulously wealthy Howard Hughes, the producer of *Hell's Angels*, who has no more regard for a million dollars than you have for last Sunday's newspaper.

The Hughes production is called *The Outlaw* but is based on the same facts as the Taylor picture. Metro-Goldwyn-Mayer had a prior claim on the *Billy the Kid* title. *The Outlaw* screenplay is by Ben Hecht, who is having a particularly good season as a writer in addition to his flyer as director of *Angels Over Broadway*. Furthermore, *The Outlaw* has a long head start on *Billy the Kid*, filming having started before New Year's at Moencopi, Arizona.

Bob Taylor's "opposite number" in *The Outlaw* is a

Meet Two-Gun Taylor

Texas kid named Jack Beutel, a beardless youth of twenty-one with an authentic Southwestern drawl and nothing to lose if his first important picture is no hotcake at the box-office. Jack's entire fortune to date consists of $150 he won at a Dallas bank nite and decided to gamble on a fling at Hollywood. Before that he had been an insurance clerk at $20 a week.

By contrast, Robert Taylor is a man of property, possessing a ranch, a stable, a town house, an airplane and all the appurtenances of a tycoon, including business troubles. His willingness to engage in a finish duel with a Johnny-Come-Lately is as sporting as if Vincent Astor were to strike up a winner-take-all crap game with a poorhouse inmate.

To be sure, Hollywood's biggest and costliest scenario department is being enlisted to fit the mantle of *Billy the Kid* to Bob's maturing figure. He will get all the best of it in lighting, costuming and camera work.

■ In the matter of horsemanship, it should not be surprising if he showed up better than Jack Beutel, the Dallas insurance clerk. Until recently Bob was the owner of ten horses which he exercised regularly at his San Fernando Valley ranch. Lately he has given away four of his mounts to cut down overhead but his hours in the saddle have not been reduced.

As part of the toughening-up process for *Billy the Kid* he went along on the arduous horseback tour of the Vaqueros this winter. The Vaqueros are a society composed of an even hundred horsemen who take an annual saddle tour of the region around San Jacinto under conditions that would try a saint. The route often covers thirty miles a day at 10 above zero; the cavaliers sleep out in the open, cook their own grub and undergo staggering hardships to prove to themselves and their colleagues that they are genuine tough guys.

Admittance to this horseback marathon is strictly by invitation. Social qualifications are definitely out. The only questions asked concerning a candidate are: "Can he ride?" "Can he take it?" and "Is he a good companion?" Bob was recommended by Valdez, the trainer of his horses, who should be in a position to testify on all these points. When he returned from the saddle safari he had a six-day beard, a second-degree case of windburn and resembled General Grant coming back from the wars.

Robert Taylor has been a good knock-about horseman since he wore knee-breeches back in Nebraska. On the farm of his Grandfather Stanhope he was practically inseparable in daylight hours from the saddle of a durable pony named Gyp. Since then no week has gone by during which he hasn't spent a good solid quota of hours with his feet in the stirrups.

Despite a certain air of ethereality that the camera discloses about his personality, there is no lack of hardness in the fellow's fibre. He has tramped his full share of miles behind a plough, shocked wheat side-by-side with seasoned harvest hands, dug postholes, painted barns and wrestled with balky farm machinery.

Western films have always been Bob's favorites. William S. Hart was a childhood idol. Tom Mix is deified in his memory. Will Rogers was the first top-flight actor to encourage Bob in his acting career, and he has always hankered to raise himself to the stature of any or all of these three by doing a standout job in a glorified horse opera.

In a screen career that has seen him as a crook, a doctor, a society man, a racketeer and an aviator (always with overtones of Great Lover) Bob feels that he has never had a real chance to show any of his built-in aptitudes. *Flight Command* pictures him as a Navy pilot but inasmuch as he has not yet soloed in his new plane he can be excused for thinking that role a bit premature.

If his part-time preoccupation with flying keeps up, however, he will soon be ripe for a realistic air role. At the beginning of his course of instruction he made up his mind to do a thorough job of committing himself to air-mindedness. He bought his own plane, a four-place Fairchild cabin job that is more difficult to maneuver than the ordinary training plane.

As instructor he hired Max Constant, the famous French speed pilot who customarily flies Jacqueline Cochran's racing plane and holds the record between New York and Miami. On days when Bob is free from the studio and his self-assigned stable duties, he spends long hours at Metropolitan Airport studying instrument navigation and radio technique and makes at least one flight each afternoon.

Currently he is trying to talk Barbara Stanwyck into redesigning the grounds of the Valley ranch so that he can smooth off a landing field where the fenced horse-training track now stands. But Barbara is holding out until Bob has had a few dozen more flights.

The other evening Bob gave his flying instructor a new thrill while practicing landings. He was coming in at Metropolitan and congratulating himself on the niftiest set-down he had yet accomplished when the plane began veering off the runway and into an adjoining garden. Bob had merely neglected to straighten out the rudder, which steered him efficiently into a watermelon patch. The elegant new plane nosed over into soft earth. Two hours later our hero was still spitting watermelon seeds.

■ *Billy the Kid* can be an upward step or a pitfall in Bob's path. Of his last five pictures, M-G-M acknowledges freely that three were not entirely successful. The sub-par trio were *Lucky Night*, with Myrna Loy; *Lady of the Tropics*, with Hedy Lamarr, and *Remember?* with Greer Garson.

Escape, with Norma Shearer, was something else again, widely appreciated by critics and ticket-buyers alike. This picture was a long time in preparation and even after it was finished the company was called back for eleven days of retakes. The retakes, it might be mentioned in confidence, were not occasioned by any shortcomings in Bob's original performance.

As in all his successful roles, however, the good notices he received for *Escape* were accompanied by peculiar backhanded implications, the kind of negative praise that has caused Bob to term himself "O. E." Taylor. The initials stand for "Oddly Enough."

It seems that dozens of film reviewers, if not the majority, are reluctant, if not downright grudging, in any praise they may vouchsafe to him. In his very first full-length part, the second lead of *Society Doctor*, he created a distinct stir in the audience and drew stacks of fan mail. Yet *The New York Herald-Tribune* set the pace for the nation's reviewers by saying, "A young unknown named Robert Taylor gave a good account of himself in spite of his good looks."

Since then the critics' Robert Taylor theme song, even referring to his most painstaking and sincere performances, has been, "Oddly enough, surprisingly enough, you wouldn't believe it, but Robert Taylor was all right in his part."

In *Billy the Kid*, the most venturesome step he has taken since setting foot on the Metro lot, Bob Taylor has made up his mind to erase that "Oddly Enough" label. He'll either do such a surpassingly good job that the qualifying phrase will be jettisoned once and for all—or muff his hard-won opportunity by such a wide margin that he'll be the first to admit it.

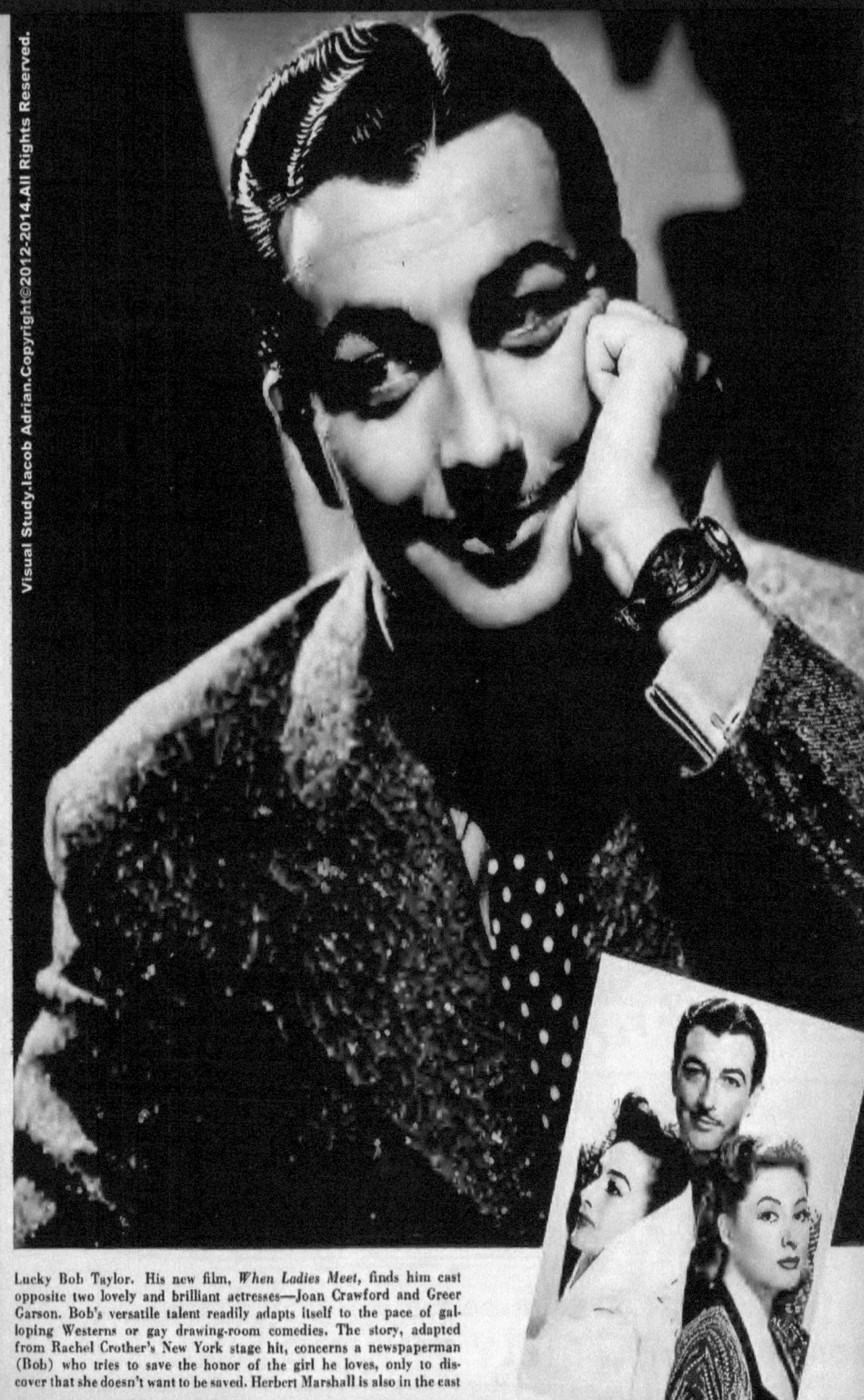

Lucky Bob Taylor. His new film, *When Ladies Meet*, finds him cast opposite two lovely and brilliant actresses—Joan Crawford and Greer Garson. Bob's versatile talent readily adapts itself to the pace of galloping Westerns or gay drawing-room comedies. The story, adapted from Rachel Crother's New York stage hit, concerns a newspaperman (Bob) who tries to save the honor of the girl he loves, only to discover that she doesn't want to be saved. Herbert Marshall is also in the cast

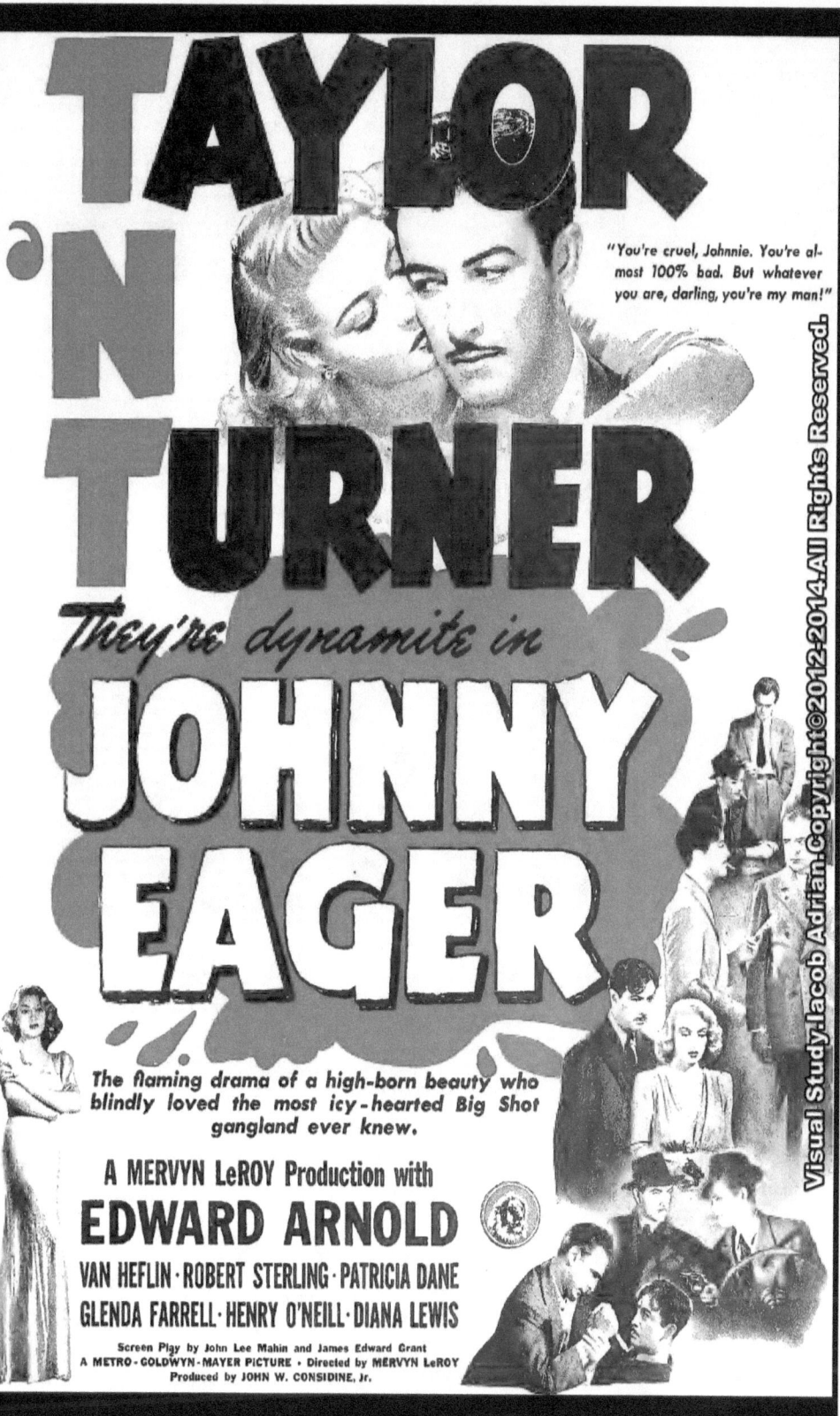

Popping Questions at Bob Taylor

Quizzed by HELEN HOVER

A. ..

Q. When did you make your most glaring faux pas?

A. At a Swedish-American Ball in Stockholm in 1937. While escorting Princess Bernadotte down the grand staircase, I caught my heel in the trousers of my full dress suit and fell flat on my ——. Regardless of what I fell on, it was emphatically an embarrassing moment.

Q. In what ways would you say that you and Barbara are most alike?

A. In the fact that we both worry, are both rather moody, and both enjoy seeing and making pictures.

Q. In what ways are you most unlike?

A. Barbara doesn't sleep well; I do—like a log. Barbara doesn't eat much; I do—like a (well, it doesn't really matter).

Q. How do you react when female fans gush over you?

A. ..

Q. When were you most discouraged about your career?

A. About three years ago after having had three or four inferior pictures and a considerable amount of questionable publicity. Believe me, I was *plenty* worried.

Q. What is your sore spot?

A. I suppose the one which *did* bother me most was that fairly decrepit one about "pretty boy." That sure used to rankle. I tried never to let on, however, and it kind of went the way of all flesh.

Q. If you could live your life over, what would you want changed?

A. I wish that my father could have lived to share part of the success that I have been able to attain. I'm sure I could have shown him a wonderful time in return for all the fine things he did for me.

Q. Have you ever overheard any unflattering remarks about yourself in a movie house?

A. Far too many times. That's why I now

Affable Bob Taylor responded eagerly when cornered by HOLLYWOOD'S quiz reporter, Helen Hover, who fired some forty personal questions at him. He is shown with two favorite pets, Princess, a Boxer, and Champ, a terrier

Above: Rated one of the handsomest men on the screen, Bob prefers tough-guy roles in Westerns. He's in *Clear For Action*

Q. What unkind rumor about yourself most upset you?

A. The one several years ago that I was going to attempt a "comeback" when I wasn't even aware that I had been out of pictures.

Q. Were you ever embarrassed doing a love scene?

A. Once or twice in *Camille*, merely because the style of the dialogue was so foreign to me that I felt like a fish out of water. It's been a long time, however, since I've felt any self-consciousness about such a scene.

Q. Do you take an interest in the way your wife, Barbara Stanwyck, dresses, and do you try to advise her?

A. Like all mere males I suppose I consider myself an authority on women's clothes. I do make many suggestions along these lines. Whether they are accepted, or whether she merely convinces me that her own preferences are "actually the very thing I was suggesting," I don't know. Needless to say, I feel that she dresses very smartly, looks very well. Thanks to . . .

Q. What type of clothes do you like most on your wife?

A. Tailored things. Suits, slacks, and simple dinner clothes.

Q. If you have any children, which of yours and Barbara's qualities and features would you want them to inherit?

Next Month

Hollywood's Quiz Reporter

puts

Claudette Colbert

on the spot

high-brow art it made up for in steadiness of work. She soon became one of the most popular actresses on the air and at one time was simultaneously acting in eight different air shows. It was through radio that she met Orson Welles, then a daring young man on the airwaves; and he promptly cast her in practically every one of his network shows. Welles once said that Agnes could play any type of role except that of *Baby Snooks*, and when he invaded Hollywood, he took her with him. While Welles' Hollywood career has been as full of ups and downs as the war news, Agnes' has risen steadily until now she is fast becoming the girl which producers think of with relief when they have a difficult part to cast.

Agnes lives quietly in a rented cottage in a modest suburb right outside of Hollywood, and when she has free time she promptly heads East to Ohio where she has a 320 acre farm and a good-looking husband, named Jack Lee. They met when they were both students at the dramatic academy. She was walking down the school steps when she heard a masculine voice behind her say, "There goes the straightest back I've ever seen on a girl." She turned around sharply and faced a grinning young man. Soon after graduation they were married. They had shared a mutual interest in acting, but Jack gave up histrionics and today he manages their large farm, while Agnes still has the acting fixation.

Between assignments, Agnes makes quick tracks to the farm where she wears dungarees, goes without make-up, pitches hay and has the time of her life. And whenever she can, Jack goes to Hollywood to be with the little woman. The arrangement has worked out successfully and they have never been separated for more than two months at a time.

This shows that Agnes is a young woman of good sense. You're right. Unassuming, well-bred, thoroughly natural, she is a happy combination of dignity and fun. She has an amazing memory for faces and when she spots a familiar face in a crowd, she is not satisfied until she places it. It's an obsession, and she can't concentrate on much else until she knows just *where* she saw that person. This is a form of goofiness which amounts to a fixation with her, and its most coincidental phase came last year when she saw a childhood picture of Orson Welles at the age of eight, in a magazine. The face was familiar and she mulled about it for weeks. Suddenly it came to her. He was the precocious, rather conspicuous little boy who once sat at the table next to hers one Saturday afternoon at the old Waldorf Hotel in New York. This memory feat amazed even the great Mr. Welles, for he admitted that his father did take him to that hotel when he was a youngster. She even described the suit he wore! Now when people ask Orson how long he's known Agnes Moorehead, he says casually, "Oh, ever since I was eight."

This sometimes leads a few people to believe that he gave her a picture break because of a long friendship. But such a thought is immediately dispelled when they see Agnes on the screen. That girl can act—and it takes only a ten minute acquaintance to know it!

Popping Questions at Bob Taylor

A. Close association with my father, a physician whose whole philosophy was one of trying to do the most good possible and enjoying it to the fullest. I certainly don't feel that I have ever compared with him in that respect, but I do believe that it has more or less determined my attitude toward the people with whom I associate and my reactions to various situations.

Q. About what are you most sensitive?

A. Two things: 1. Personal cleanliness. 2. The opinions of people toward me. I make a sincere effort to make myself generally well-liked.

Q. Do you believe in matrimonial vacations?

A.

Q. What unbecoming personal mannerism have you had to overcome?

A. Wearing a frown when there was actually nothing to frown about.

Q. What type of role do you like Barbara to play? And in your opinion, what has been her best role?

A. I like her both in comedy and highly dramatic parts. However, I believe she excels in the latter, not so much that she can't do comedy, but that there are so few really fine dramatic actresses. To my way of thinking, *Stella Dallas* was her best performance.

Q. What famous person would you like to meet—and why?

A. Hitler—because the only place I'd have a chance of meeting him would be in the Army; he as an unwilling guest of the U. S. Army. And because that's where he ought to be, and because that's where he *will* be some day, so help me!

Q. What type of role would you most like to do?

A. I don't know whether or not I have any ability along those lines, but my personal likes in pictures and in personalities make me lean toward Westerns. As far as my actual preference goes, I'd just as soon do all Westerns and forget about drawing room comedies and immortal love stories.

Q. On what subject do you consider yourself most uninformed?

A. Politics and economics. And I say that without shame. Show me anyone who can keep up with the political and economic status of things today and I'll show you a man who's well on his way to the nut-house and a straitjacket.

Q. In what ways do you give in to Barbara?

A. I'm afraid that most of the giving in is on her side. I have pretty definite opinions about a lot of things (so does she, for that matter), but she seems to let me do an awful lot of deciding. That old female intuition, I guess.

Q. What player would you most like to work with, and why?

A. Innumerable ones, but preferably with Spencer Tracy. Why? An actor as good as he always makes you look better when you are working with him. And I'm not being modest—that's the way I feel about Spence.

Q. What would you say is your worst failing?

A. The ability to worry when there's really nothing to worry about.

Q. What do you think are Barbara's best traits?

A. Honesty, philanthropy and simplicity.

Q. What personal accomplishment was most difficult for you to acquire?

A. I guess golf came the nearest to stopping me. I finally had to choose between a nervous breakdown or one more attempt to break an 80, so I did neither and quit the game. I still have my clubs, however, being too thrifty by nature to throw them in the lake.

Q. What role pleased you the most?

A. It's a toss-up between *Waterloo Bridge* and *Johnny Eager*.

Q. Have you an urge to do a stage play?

A. None whatsoever! I get weak in the knees, butterflies in my stomach and cotton grows in my mouth at the very thought of getting on a stage before a "live" audience.

Q. Why did you and Barbara give up your ranches?

A. Partly for financial reasons, partly because of the distance they were from our work. When you have to get up at 4:30 in the morning in order to be ready for work as Barbara did—well, *fun's fun*.

Q. Who does most of the talking at the dinner table?

A. I honestly believe that this is pretty much a give and take proposition. I might say, however, that inasmuch as I eat considerably more than Barbara, I'm afraid that my attention is all too frequently on my plate rather than on the subject of conversation.

Q. Have you a pet subject about which you like to discuss or argue?

A. None. Coming from a very argumentative stock of Scotch, Dutch and Irish ancestry, I am perfectly willing to take either side of an argument, discuss the subject to the limits of my knowledge, and may the best man win.

Q. Would you like to have children some day?

A.

Q. What is the name of your latest picture?

A. *Clear for Action*.

Q. Do you get depressed easily?

A. Have you ever heard of crawling under a snake's belly? That's me!

Bibliographic sources :

Hollywood (1934-1943)
Publisher: Hollywood Magazine, inc. ; Fawcett Publications, inc.

This documentary study use,
combined in various proportions,
elements from the following categories,
forms and subsets :
- fair use
- documentary
- documentary photography
- feature
- journalism
- arts journalism
- visual journalism
- photojournalism
- celebrity photography
in order to :
- employ material as the object of cultural critique ,
- quote to illustrate an argument or point ,
- use material in historical sequence,
providing independent opinion,
using photos, press articles, advertisements,
opinions of fans etc. ...

Copyright©2012-2014 Iacob Adrian.All Rights Reserved.

www.ingramcontent.com/pod-product-compliance
Lightning Source LLC
Chambersburg PA
CBHW021039180526
45163CB00005B/2189